ONE is
ADAM
ONE is
SUPERMAN

The Outsider Artists of Creative Growth

Photographs by Leon Borensztein

Essay by John M. MacGregor
Introduction by Tom di Maria

CHRONICLE BOOKS

SAN FRANCISCO

Photographs copyright © 2004 by Leon Borensztein
Text copyright © 2004 by Creative Growth
Preface copyright © 2004 by Leon Borensztein
Essay copyright © 2004 by John M. MacGregor
Introduction copyright © 2004 by Tom di Maria
All rights reserved. No part of this book may be reproduced
in any form without written permission from the publisher.
Library of Congress Cataloging-in-Publication Data available.
ISBN: 0-8118-4531-1

Manufactured in Hong Kong
Designed by Sara Schneider

Distributed in Canada by Raincoast Books
9050 Shaughnessy Street
Vancouver, British Columbia V6P 6E5

10 9 8 7 6 5 4 3 2 1

Chronicle Books LLC
85 Second Street
San Francisco, California 94105
www.chroniclebooks.com

This book is published in conjunction with the exhibition "LEON BORENSZTEIN AND
HIS FRIENDS: portraits of artists with disabilities," organized by the Yerba Buena Center
for the Arts, San Francisco. For more information on exhibitions, please contact
Creative Growth Art Center at 510-836-2340 or www.creativegrowth.org.

for Sharon

You opened my eyes
and showed me
how to see with my heart.

PREFACE

*I don't believe that the task of an artist
is to applaud, flatter, or judge,
but rather
to question, to provoke, to inflame,
and to incite.*

I am a father.

When my daughter was born, she fell under the category of a "special child." Indeed, she was very special; she was born with multiple handicaps.

How, in one short paragraph, can one describe all the heartbreak associated with being a parent of a disabled child? How deficient on wisdom and patience we are, and how unrelenting is the anguish of facing the constant medical problems, ongoing therapies, the complexity of "special education," and the heartless bureaucracy that was created to help you and your "special child"! And how painful it is to witness others making fun of your disabled child! How hurtful it is to see your social life fading and friendships vanishing! No less agonizing is the absence of reason in my interactions with my daughter; but above all, the dominant emotion I feel is an omnipresent despair and paralyzing fear regarding her future.

In pursuit of deeper understanding about life with disabilities, I came upon the Creative Growth Art Center in Oakland, California, an organization dedicated to providing artistic enrichment for adults and young people with developmental, physical, and emotional disabilities. Fifteen years ago, I started to photograph there. As the father of a disabled daughter, I have been troubled by the way many photographers portray people with disabilities, especially those with mental disabilities. For this reason, I want to do all I can to change the stereotypes of the disabled and concentrate on the range of their potential as opposed to their limitations. Therefore, through my portraits, I try to portray even the most severely physically or mentally disabled person in an honest, positive, and sympathetic light.

My belief is that the camera doesn't lie; it is just a dispassionate tool.

Many of my subjects at Creative Growth have a hard time controlling their facial expressions or their bodies. In the blink of an eye, the face can undergo countless transformations, from entirely painful and contorted to very relaxed, calm, and joyful. Each and every expression represents a reality, a true rendition of a moment. When I capture the range of those emotions with my camera, the question arises: How do I decide which one to choose, which one to use?

As a photographer I am drawn to the stronger, more striking images. But, as the father of a "special" daughter I am attracted to the less dramatic images, the ones that are more dignified, the ones that flatter.

Looking at my earliest portraits of Creative Growth artists, friends questioned whether all of my subjects were really disabled. I realized then that by trying to portray them in an upbeat, positive, and flattering way, I had transformed them into something that they were not. I had missed the whole point of this project. Therefore, I decided to be positively objective, not hiding their disabilities but not accentuating them either.

At the beginning of this project, I couldn't photograph more than two or three people a day. My visits to Creative Growth were exhausting physically and emotionally, exacerbated by the fear, pain, and agony connected to being a father of a disabled child. I didn't even ask for the names of the people I photographed; I just wanted to take the pictures and leave. As the years passed, my attitude and comfort level changed; I learned their names, and they learned mine. After my initial discomfort, I found that I couldn't wait for the day to arrive for me to photograph or conduct the interviews. Whenever I

go there now, I am greeted with handshakes, hugs, big smiles, sometimes a bit of bashfulness, and, most important, with open hearts.

Quite often, I found myself watching the extraordinary talent that many of the clients are blessed with, a gift I wished for myself. I was also mesmerized by the enormous effort that it takes for some of them, with severe physical limitations, to simply hold a pencil or a brush, or just to move a hand. And how beautiful are the delicate lines emerging from under the stiff, inflexible, feeble, often distorted fingers! How wonderful and amazing are the shapes of the clay or the wood slowly emerging from under the same hands! And the incredible, delicate watercolors created by artists like Sharon Spencer, who used her mouth to hold a brush! The passion, the commitment, the perseverance of those individuals is so enormous that sometimes it borders on heroic.

Here at the Center I learned to stop feeling sorry for myself.

One of the more challenging parts of this project was choosing only one work by each artist to be included in this book. It was terribly frustrating to go through one magnificent body of work after another, each spanning a creative lifetime, and reject all but one work of art from each. In the end, I chose intuitively, and each piece featured in this book reflects the emotional impact that work had on me during the selection process.

During the interviews, as I became aware of the richness and complexity of the artists' personalities, I encountered another dilemma: Some of the artists expressed "politically incorrect" personal viewpoints in their statements. My initial reaction was to omit them, but because my goal for this project is to show the range of these artists' abilities, I finally came to the conclusion that it would be fitting to extend that very approach to their personalities and beliefs and not edit them. Some may be provocative, some may be distasteful, but all are real.

A few years ago I received an assignment to photograph a large spread for a leading international men's fashion magazine. To promote the cause of people with disabilities, I decided to use clients from Creative Growth for some of the shots instead of professional models. The publisher loved the photographs and objected to one only, a shot of a person in a wheelchair. In their eyes it was an offensive image. I mentioned to the company president that just a few months before they had published photographs of people engaged in sex. The answer was, "Sex sells, a wheelchair doesn't," and they published a similar image but without the wheelchair.

As a photographer, I use light to transform a negative into a positive. The artists presented in this book have done the same for me. This experience has been invaluable to me as a father of my own disabled daughter. I honor their talent more than I bemoan their disability and their Outsider status. As I struggle to understand the workings of my daughter's mind, I often feel that *I* am the outsider, trying to break through the tangled web that separates us, that thwarts the possibility of a true I and Thou. At Creative Growth, art becomes the prevailing language that untangles this web and enriches our own lives no less than those of the artists. For this we are grateful.

Leon Borensztein

CREATIVITY
AND
DISABILITY

It is a paradoxical fact that, after age seven or eight, individuals of normal, even exceptional, intelligence rarely manifest artistic creativity of any kind. So "normal" is this creative inhibition that it is not seen as worthy of comment. In the area of pictorial creativity (image making) this creative block is dismissed with the casual observation, "I can't even draw a straight line." The simple truth is that those of us blessed with a normal or above-average IQ are usually totally incapable of giving expression to, or communicating, any aspect of our personal reality in the form of drawings or paintings. This is not seen as a surprising limitation or a serious disability.

The ability to create meaningful images reflective of the world or the self is assigned to a small group of "gifted" individuals called artists. Even in this special group, real originality of vision, as opposed to mere skill at representation, is an extraordinarily rare accomplishment. Were it not for occasional artists of wide-ranging genius, we might legitimately raise the possibility that artistic ability is interfered with or obliterated by intellect.

This book, the outcome of a passionate and lifelong involvement with people who are severely intellectually challenged and/or mentally ill, confronts us with the opposite possibility, that severe intellectual disabilities can allow for the emergence of unusual, even outstanding artistic abilities. All of the works of art chosen for reproduction in this book have been created in the context of extensive intellectual, neurological, or psychological difficulties.

Creative Growth Art Center, in Oakland, California, has, for thirty years, provided an opportunity for an ever-growing number of handicapped men and women to involve themselves seriously with the making of images and objects on a daily basis. In a large, fully equipped art studio they enjoy the same freedom and intense preoccupation with images enjoyed by any committed artist. Their all-day, five-day-a-week devotion to image making has resulted in an unanticipated explosion of creativity, and the creation of works of astonishing intensity, pictorial inventiveness, and beauty. Several of the Center's client-artists (draftsmen Dwight Mackintosh and Donald Mitchell, fiber sculptor Judith Scott, and painter Kerry Damianakes) have achieved international fame as Outsider Artists of importance; their work is housed in museums, dealers' showrooms, and private collections in America, Europe, and Asia. However, it is all the artists of Creative Growth Art Center, active now or in the past, who form the subjects of this book: their works and their words, combined with the photographic portraits of them made over many years by photographer Leon Borensztein.

While we might like to believe that mentally ill or intellectually impaired people find full acceptance as active and contributing members of our society, on equal terms with the rest of us, such a belief represents, for the most part, wishful thinking, lack of experience, or calculated avoidance of the truth. Away from the safe and stimulating environment provided by Creative Growth, the men and women depicted in these portraits exist as social outsiders, marginally accepted as Outsider Artists, but otherwise excluded from real participation in society, and from real acceptance as human beings. The controversial term "Outsider Artist" expresses both this isolation and lack of acceptance, and, at the same time, the uniqueness and importance of their pictorial conception of the world. The striking works created by these artists fully embody the radical nature of their sometimes painful, often joyous, experience in it.

Outsider Art, an exceedingly rare form of human pictorial expression, has probably always been created. Dismissed as simpleminded or incomprehensible, and as having no aesthetic value and no history, most of it was thrown away. Only in the twentieth century did it begin to find acceptance as art, slowly being taken seriously in advanced art circles, being written about and studied, and

ultimately entering museums, as well as being bought and sold on the art market. One result of this acceptance of a newly fashionable form of art is that the term "Outsider Artist" (1972) and the precisely equivalent European term "Art Brut" (1945) have begun to be challenged as pejorative, usually accompanied by the overused and simpleminded rationale, "Outsider Art is now inside." This unexamined cliché is intended to suggest that since the works of Outsider Artists have begun to enter the mainstream of art, the creative individuals responsible for their invention should no longer be described as "outsiders." However, while it is undeniably true that in a still somewhat rarified and sophisticated artistic milieu these drawings, paintings, and sculptures have been recognized as powerful works of art, worthy of inclusion in museums and private collections on terms of equality with works by professional artists of fame, it is no less true that the handicapped artists who give birth to these images and objects still exist as isolates on the edge of our society. While their creations may hang in Manhattan apartments, beside the works of Picasso, Pollock, or Bourgeois, the creators are unlikely to be invited to set foot in these same apartments, their appearance, their behavior, and the reality of their being leading to their exclusion from polite society. While Outsider Art is unquestionably "in," Outsider Artists remain as far "outside" as they have ever been.

It is also sadly true that for the most part the meaning of their creations is overlooked in such environments. Their embodiment of massively different states of consciousness, or of a radically different view of the world, is seen as a new, slightly strange, undeniably original but essentially decorative arrangement of forms, void of meaning. The failure to explore or to attempt to understand the unique nature of the various forms of experience underlying these works represents an additional form of exclusion, and a denial of the reality so powerfully present in these creations.

As raw, primitive, or obscure as the form and content of these works may occasionally be, the meanings they give voice to are as complex, multileveled, richly symbolic, and indeed as relevant as works executed by professional artists. In most, but not all, an audience is being sought, an attempt is being made to share something of importance. This can involve a creative gesture of unusual courage and honesty. Occasionally we come up against images so subjective, so idiosyncratic, as to be all but incomprehensible. At times a drawing, painting, or object serves only as a means of orientation or "ordering" in a confusing or chaotic perceptual world. Other artists are preoccupied with realizing an internal vision, and in giving form to their experiences of unfamiliar, often radically different mental states. It is the task of all art, Outsider or otherwise, to capture unique forms of human experience and feeling. No human reality, no matter how unusual, strange, confused, or frightening, can be allowed to fall outside the territory of art.

While numerous publications on Outsider Art are now readily available, this book is unique. Leon Borensztein's radical decision to present the portraits of the artists along with their works may offend some fainthearted individuals who would prefer to preserve the "anonymity" of these creators, as though their physical presence is best concealed from view. Yet, even a casual glance at these vibrant portraits makes it more than evident that these artists are proud of their pictorial achievements, identifying with their works. Their relationship to the objects they have created is no less complicated, no less personal, and no less important than any other artist. It is evident that each artist has welcomed the idea of being photographed with his or her work.

Confronted with their physical presence (and not a little of their reality), along with their words and works, we may risk feeling, responding to, and understanding more of their existence. In their presence we may consider more thoughtfully the nature of their life experience, and grasp, with greater insight, the powerful, sometimes disturbing forces that have shaped the images to which we give the name Outsider Art. In these portraits Leon Borensztein has recognized and explored the connections that exist between an individual's physical and psychological reality and his works of art. His photographs capture the tenuous yet significant connections between life and art, while seeing in both a valuable contribution made by a generally ignored and undervalued group of people to all of mankind.

John M. MacGregor, Ph.D.

INTRODUCTION

Creative Growth Art Center is celebrating its thirtieth anniversary as the oldest and largest independent art center for people living with developmental, physical, and mental disabilities. In our studio and gallery in Oakland, California, more than 130 adult artists work with paint, clay, wood, fiber, and other media to create thousands of art objects annually. These pieces are displayed and sold in our gallery, and at museums and galleries around the world. This model of artistic self-sufficiency, creativity, belief in human potential, and support for the aesthetic potential in every human being has been our driving force since our inception in 1974.

In our art studio, process is paramount. Our artists confront and explore the dilemmas faced by human beings since the dawn of art making: What should I make? What should a work of art convey? What should it look like? Our artists' work also serves as a primary, or sole, form of communication with the world outside. For our clients who are non-verbal or less communicative, these art objects form a direct and powerful link between the artist and the viewer. Created by a process that may be a mystery to us, these objects speak clearly about the maker, the nature of creativity, and our commonalities as human beings.

Leon Borensztein is an inquisitive photographer—and his work is about process and product, too. His portraits of our artists explore and dismantle the barriers between us and them, self and other. His photographs lift the encounter to the common ground of artist meeting artist, communicating in a private moment that is then generously shared with us.

Photography is often about capturing a sense of time, and Leon's contact sheets reveal this to us. These frozen moments, transitory between the frames, are a sliver from the artist's life. The process of creation, and the many decisions made or not made, result in an image depicting the artist as he or she is at that moment.

Leon has captured our artists. Fixed on silver, these images of lives in progress, ever changing, captured momentarily, are now a part of our enduring history. I invite you to share in his work and theirs, and to experience the spirit, the lives, and the work of the artists of Creative Growth.

Tom di Maria
EXECUTIVE DIRECTOR, CREATIVE GROWTH ART CENTER

A note about the contents of this book:

Each page spread in this book features a photographic portrait of an artist or artists, along with one color reproduction of their art and a personal statement from, or about, the artist(s).

All the artwork in this book is untitled and undated. In the artwork captions, height precedes width.

The photographic portraits of the artists were taken over a twelve-year period, from June 1991 to January 2004.

The statements and writings from the artists are taken from interviews performed at Creative Growth by Leon Borensztein in 2003 and 2004. Typeset text has been transcribed from those interviews, while handwritten words are the artists' own. In some cases, Creative Growth artists were unable to communicate verbally or in writing, and so members of the Creative Growth staff have written brief descriptions of those artists and their work. Any type not set in boldface is a statement from a Creative Growth artist.

The Artists

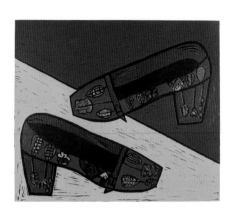

LINOLEUM BLOCK PRINT, 16" x 19"

I born like this I born like this because this is the way Lord created

me. He make me like them other thigs like I can be a
Professional like buildng houses
This is way the lord Create me like that. I went to governmet jobs didn't
give me no job, nothing.

Juan aguilera

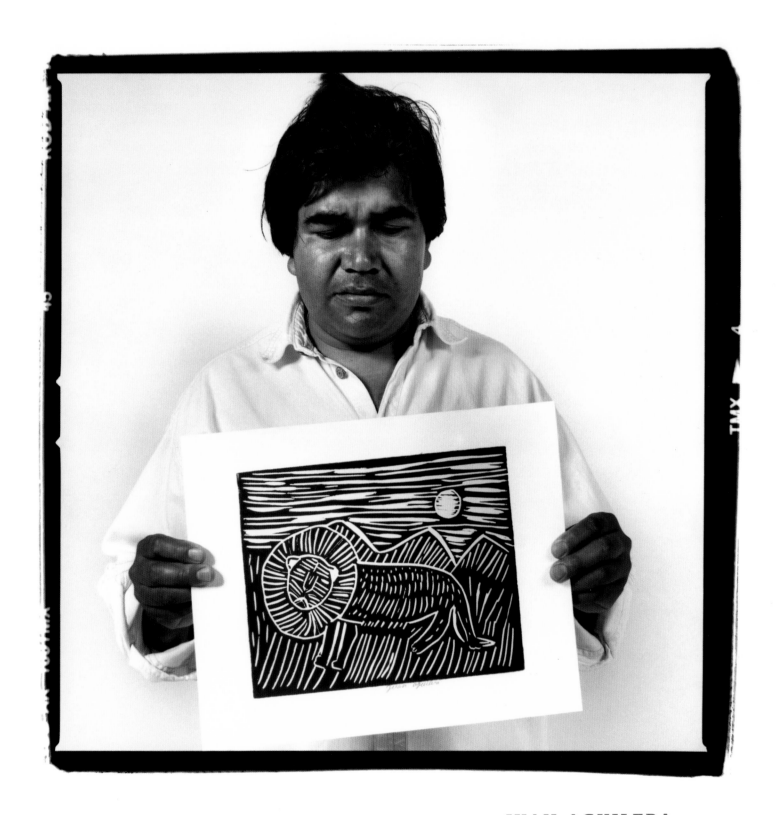

JUAN AGUILERA

I like work with wood best. It took me 10 years
to make the table.

The cats wear glasses to see better.

I like cats. They quiet. Cat is happy.

It is nice, I like to work.

I like to draw people, mostly woman, my
friends and from magazines.

My friend is Aurie. I have a lot of friends here.
I have five friends here.

PRISMACOLOR STICK, 15" x 18"

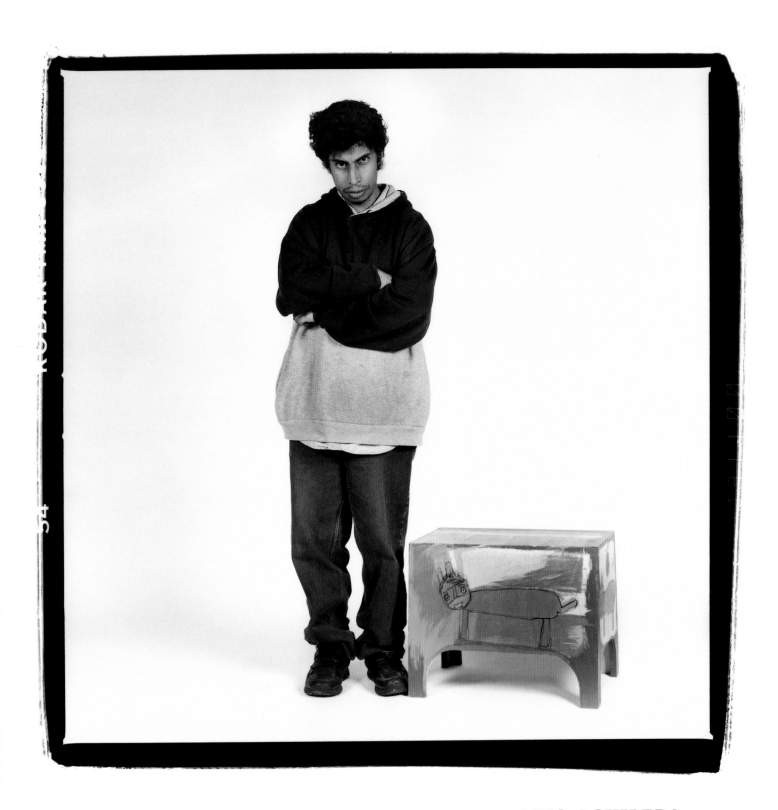

LUIS AGUILERA

When Merlin comes to Creative Growth he gets a hair dryer to blow-dry his very short hair. He finds comfort in the heat.

He is a creature of habit. He has a consistent drawing stroke that when built up becomes almost three-dimensional and lustrous.

He may be ambidextrous. He doesn't speak but communicates with gestures and head movements.

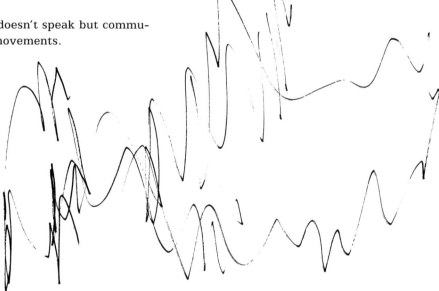

PRISMACOLOR PENCIL, 18" x 24"

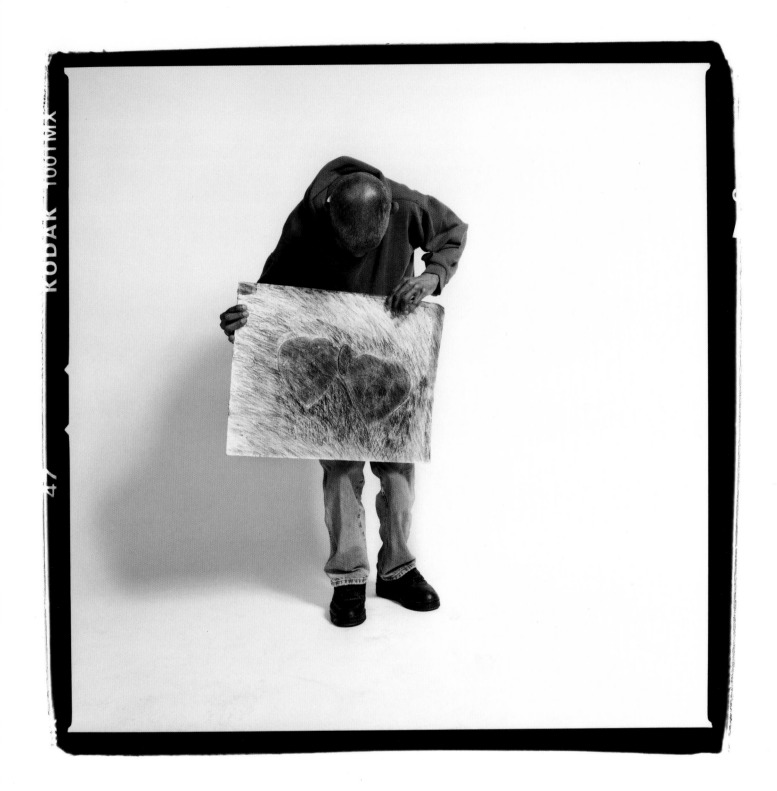

MERLIN ANTOINE

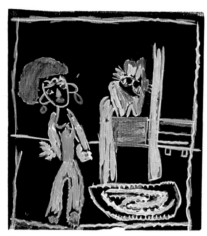

SHERRIE: LINOLEUM BLOCK PRINT, 5" x 7"

I miss max alot he was my Best friend To me I miss calling him alot. max is #1 To me I Like a photo of max and me

Sherrie
Aradanas

I enjoy creating art it is the only thing that brings me happyness in my life. the people around me give me what i need To creat art. And I see myslfe as a very good person as well as a good artist. the thoings that Happing to me are affet my art as well as my life

Maxwell

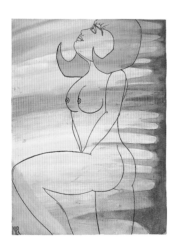

MAX: MIXED MEDIA, 30" x 22"

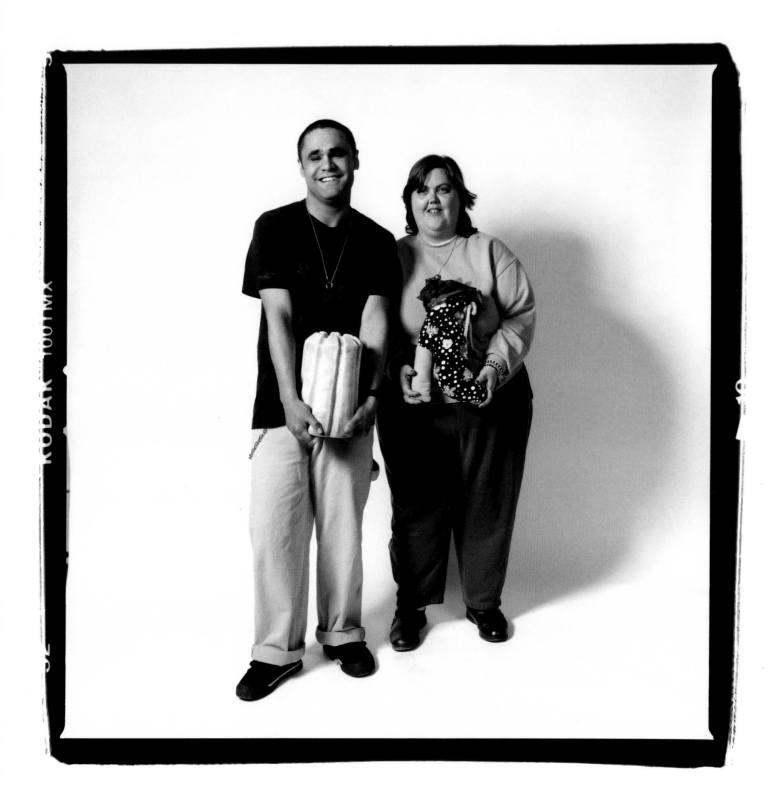

SHERRIE ARADANAS / MAX QUESADA

Jo Pe PaUl
I Miss him
Where
Is My
PaUl
Man
He Is nIce
Man

MARY

WATERCOLOR, 18" x 24"

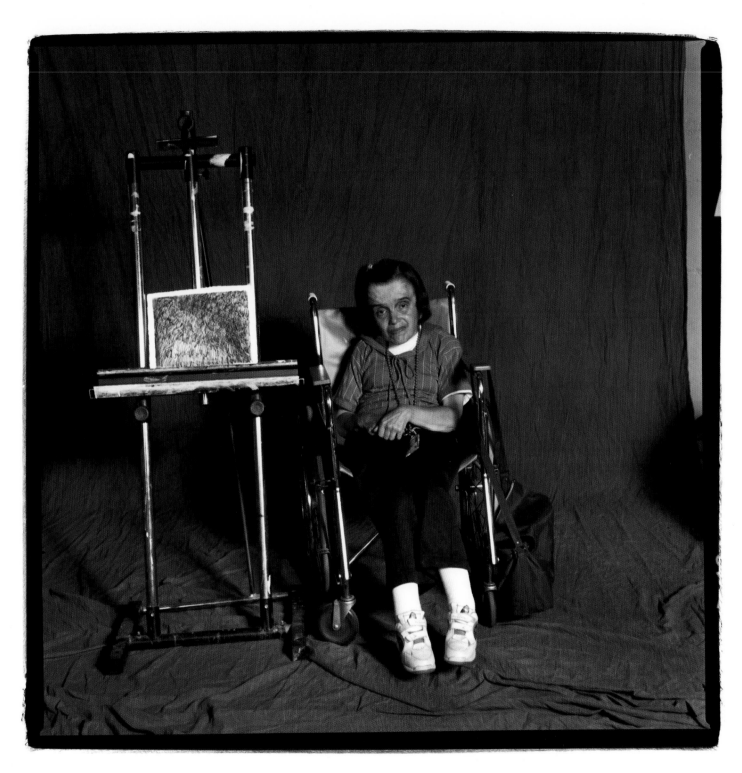

MARY ARGENTIERI

PAULCOSTA

IMLKS

Mar. 61

Paul Costa
Loves
Mary

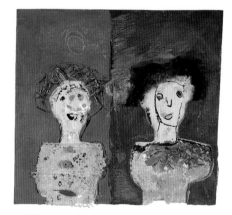

MIXED MEDIA, 8" x 8"

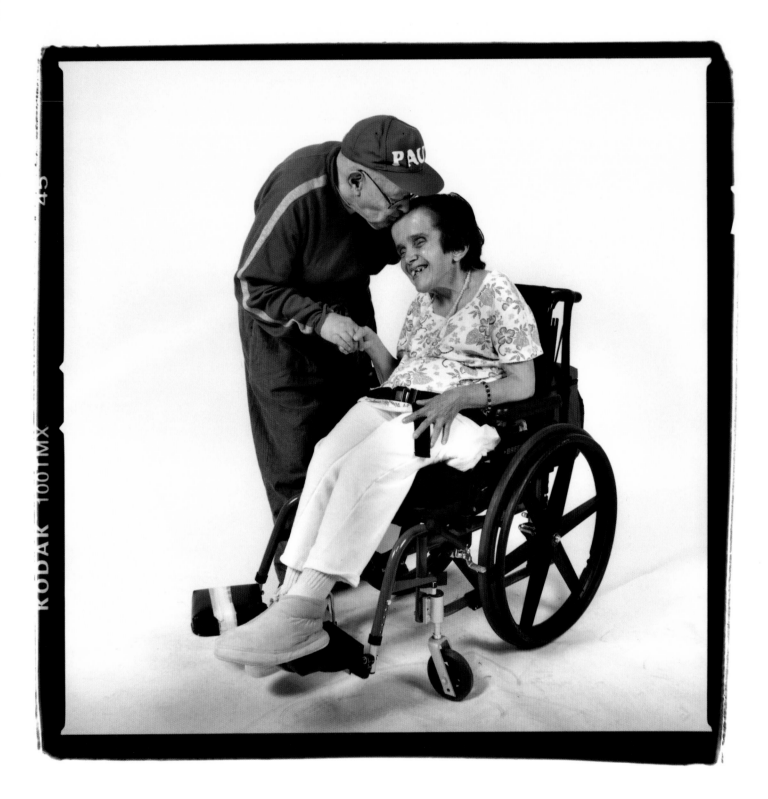

MARY ARGENTIERI / PAUL COSTA

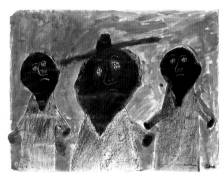

MIXED MEDIA, 18" x 24"

I always feel sad three black man
are sad

Idres Batten

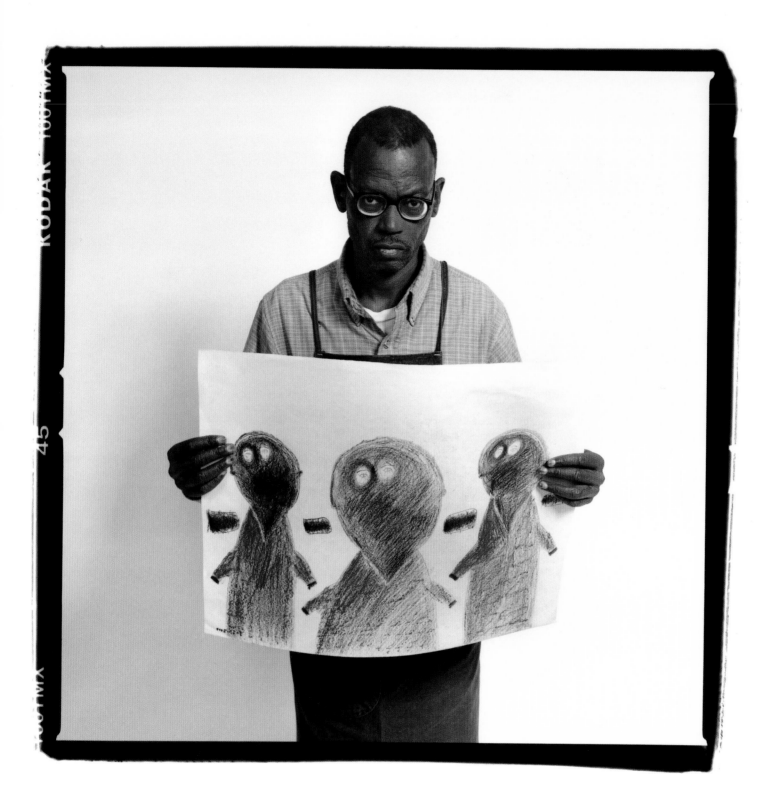

IDRES BATTEN

MIXED MEDIA COLLAGE, 5" x 7"

I was born with spina bifida. My childhood was very challenging. I didn't learn how to walk till I was 4 years old. Yes that was quite challenging. Now I have seizures, but with the implant in my head life is more tolerable.

At Skyline High School they treated me equally. I didn't have many friends, but I didn't feel left out. I had a few good friends, but I was too busy to spend my time with them. I was fortunate that nobody bothered me in this school.

I have a learning disability. This is challenging, but I am dealing with it.

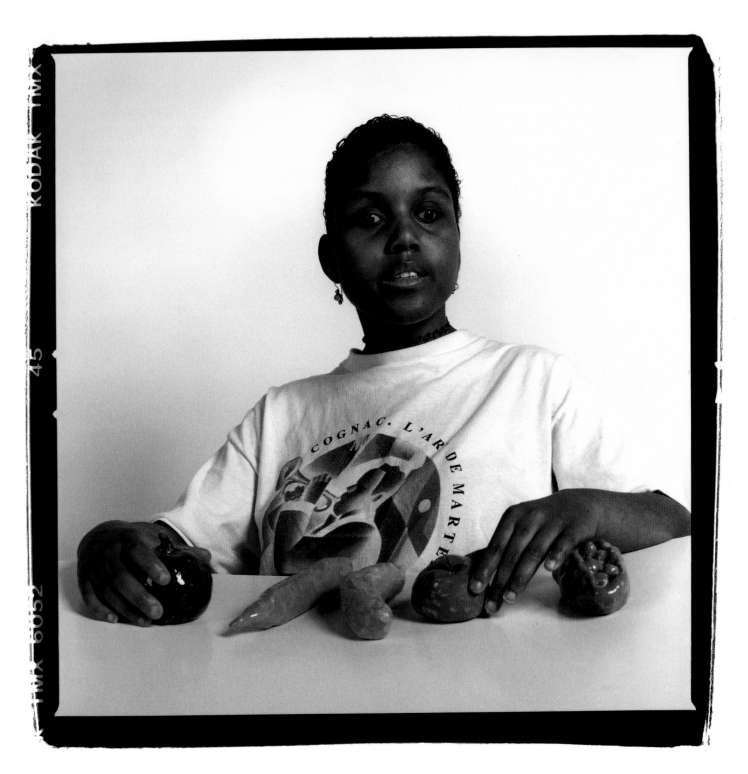

ASYA BLANKENSHIP

I don't have any
heroes, but I like
to watch the
ducks ~~&~~ swim.

Terri Bowden

LATEX PAINT ON WOOD, 20" x 7" x ½"

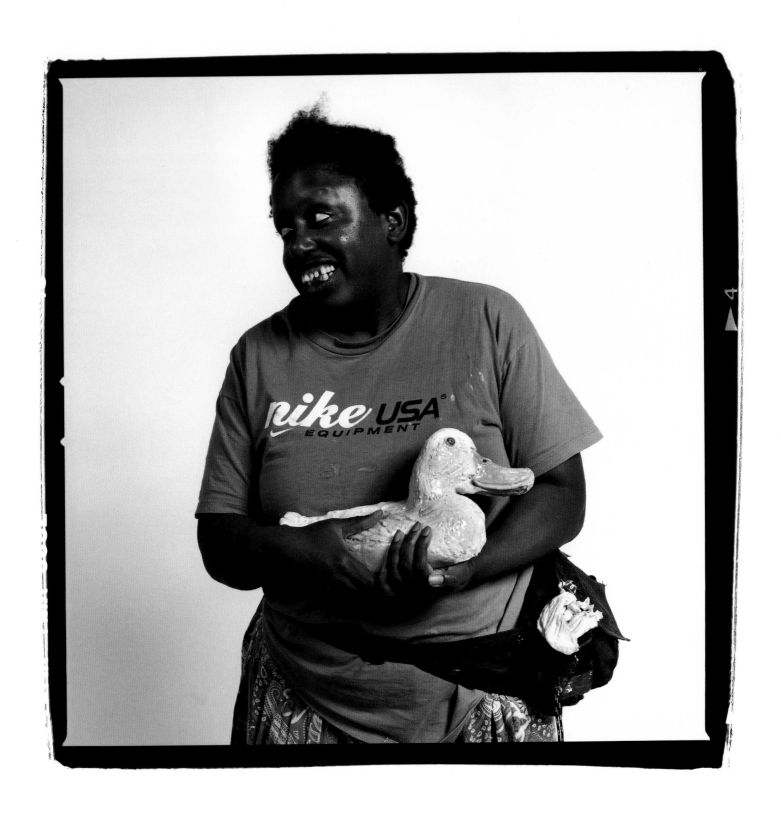

TERRI BOWDEN

This me.
That me again.
This is squirrel.
That night.
Star. Moon.
Squirrel.
Heart. Valentine.
I like squirrel.
I smiling here.
I not smile here.
I not smile here.
That squirrel black.
That squirrel white.
I like watch squirrel.
Squirrels on tree.
I watch squirrels on tree.
I watch them many times.
I watch them big time.

REGINA GRACE BROUSSARD

PRISMACOLOR MARKER, 22" X 30"

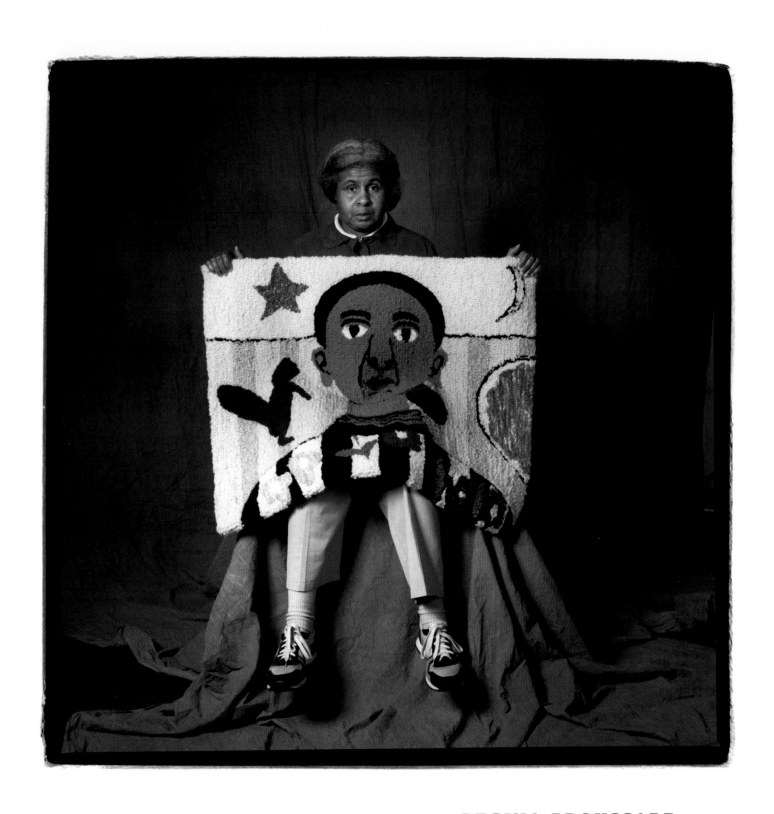

REGINA BROUSSARD

I do good job. I enjoy doing celebrities.

Usher is celebrity.

His necklace is kind bigger.

The eyes are bigger, shorter.

He is big.

Strong.

I like him.

My eyes are like raindrops.

my mouth is like an apple, I have candy lips.

he looks strong and muscles

I like his chest stomach arms

his hair necklace shoulders

its kinda shaped circle

grey and white

I like him to be my boyfriend

Kim Clark

From left to right:
LATEX PAINT ON WOOD, 24" x 8" x ½"
LATEX PAINT ON WOOD, 27" x 8" x ½"
LATEX PAINT ON WOOD, 24" x 8" x ½"

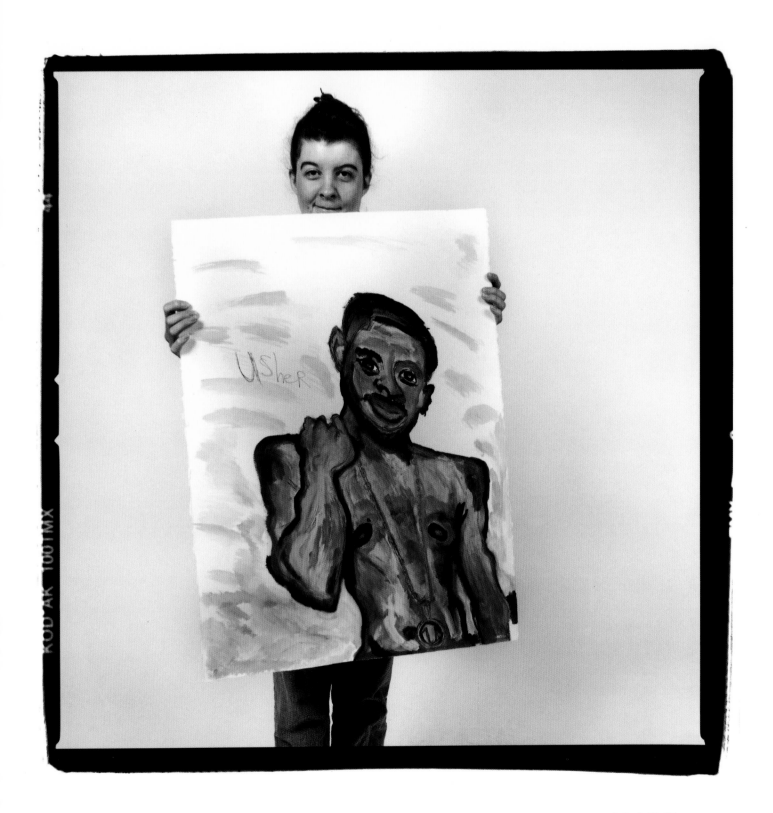

KIMBERLY CLARK

Tell me something about this picture. Where did you get the inspiration, where did you get the idea for this picture?

Well, I was going through this book of Leonardo da Vinci. And I thumbing through it and I saw these ladies and it was all over two pages. And I picked one out and it was her; where she was turned her head and her eyes were closed. And her hair was just all bundled up like it is and it was beautiful.

She seems very beautiful.

Yeah. She is very classically beautiful.
And he – I said Leonardo knows where to look for his art.

Leonard Donlad Coughran

PRISMACOLOR PENCIL, 12" x 18"

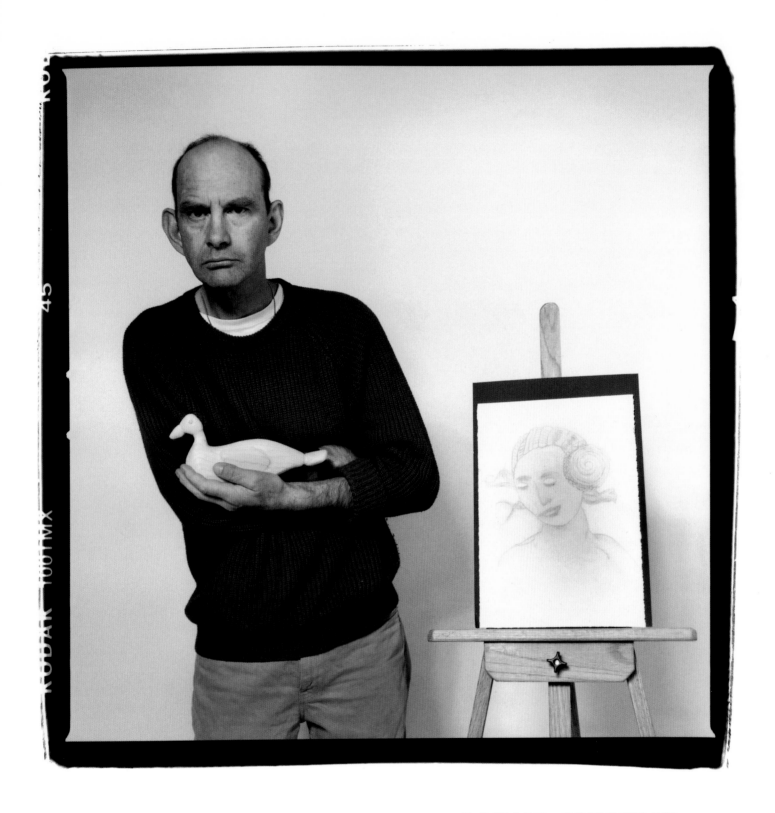

DONALD COUGHRAN

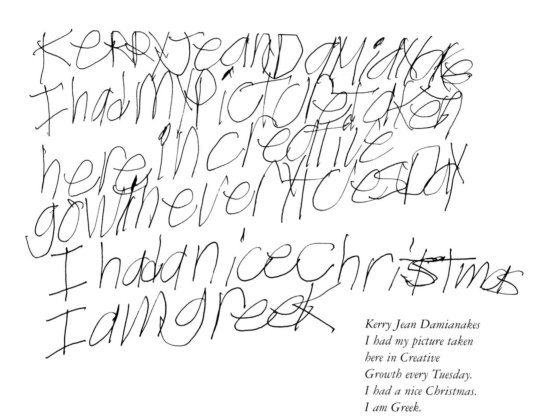

Kerry Jean Damianakes
I had my picture taken
here in Creative
Growth every Tuesday.
I had a nice Christmas.
I am Greek.

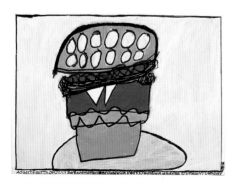

OIL PASTEL ON PAPER, 22" x 30"
TEXT READS: A short Fourth of July BarBQue Hamburger Sandwich
Kerry Jean Damianakes June 24 Tuesday 1997

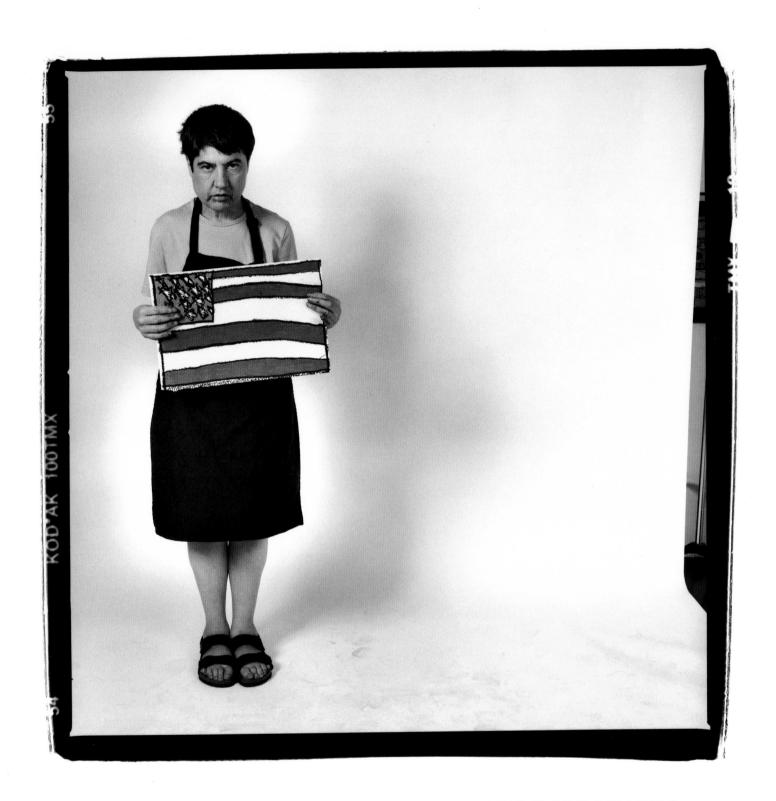

KERRY DAMIANAKES

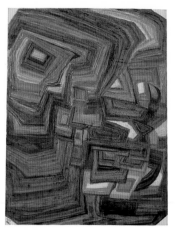

CRAYON ON PAPER, 24" x 18"

Do you like your photograph?
This is my photo. Yeah. This is beautiful.
It is beautiful.
Yeah. Beautiful.
The picture. The colors.
It takes me month to make this picture.
I am thirty now. Yeah, I am.
I like here. I like to come here.

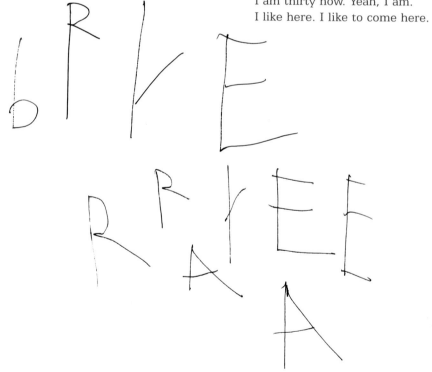

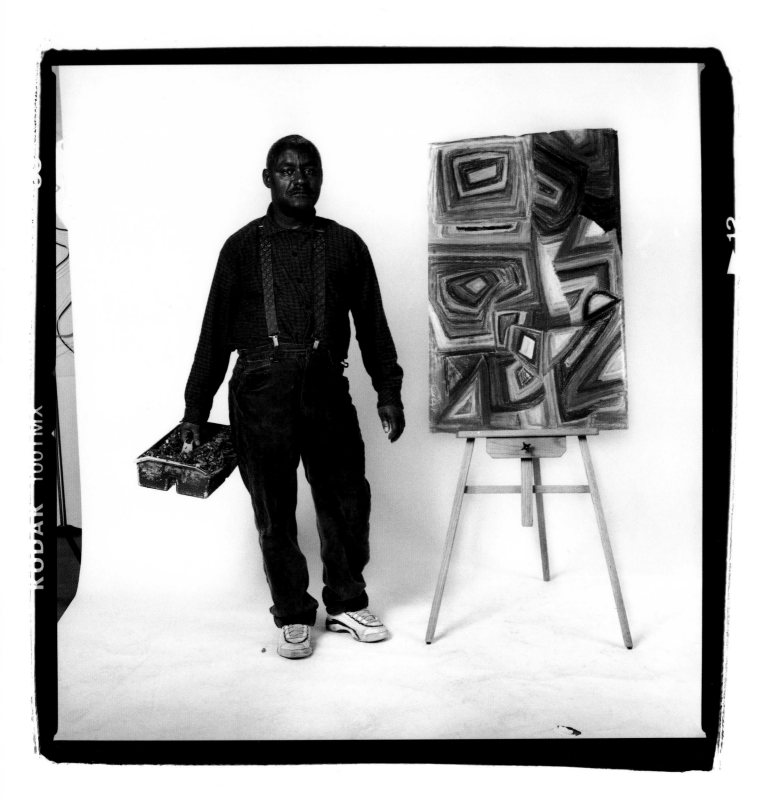

RAYDELL EARLY

Anthony loved to tell all visitors to the Center that he was a great artist and had a business card printed to that effect.

His drawing and small ceramic sculptures are funny and whimsical, usually of little animals and little people.

Some of his many truisms:

"Never say bad things in front of other people's backs."
"Never put your tongue on someone else's hamburger."

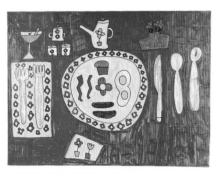

PRISMACOLOR MARKER, 12" x 18"

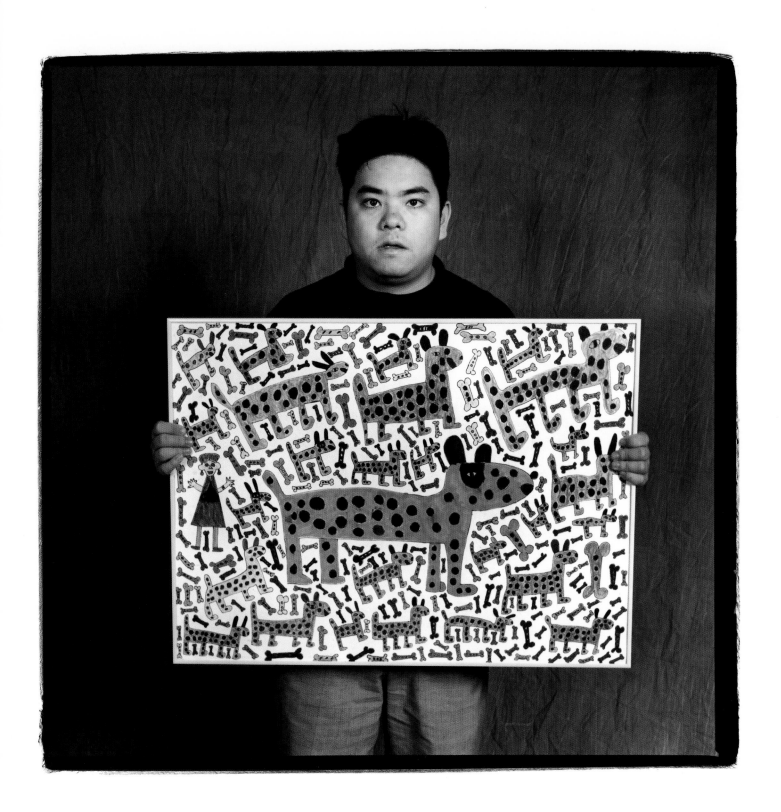

ANTHONY ENG

ADAMA AND EVE DISOBEY GOD. WHEN THEY
AAT THE FRUITE FROM THE FORBIDEN TREE.
AND THEY BOU BROUGHT SIN INTO THE WORLD.
THEN. GOD HAD TO SEND HIS ONLY BEGOTEN SON
INTO THAT PEOPLE WOULD. BES AY.
LOVE GOD AND CARE FOR HIS PEOPLE
MONEY ORE GOD. ~~~~~~~ SOME PEOPLE EAGER FOR
MONEY AND PUT GOD ASIDE. JESUS IS THE
GATE NOT MONEY OUR PEOPLE. OR ANYTHING BUT
JESUS.

I LIKE MAKK MY ARTWORK. I BEEN WORKING
HEER FOR 39 YEARS AT MY CENTER, I LIKE
WOODWORK. AND PAINTING.

LATEX PAINT ON WOOD, 5" x 24" x ½"

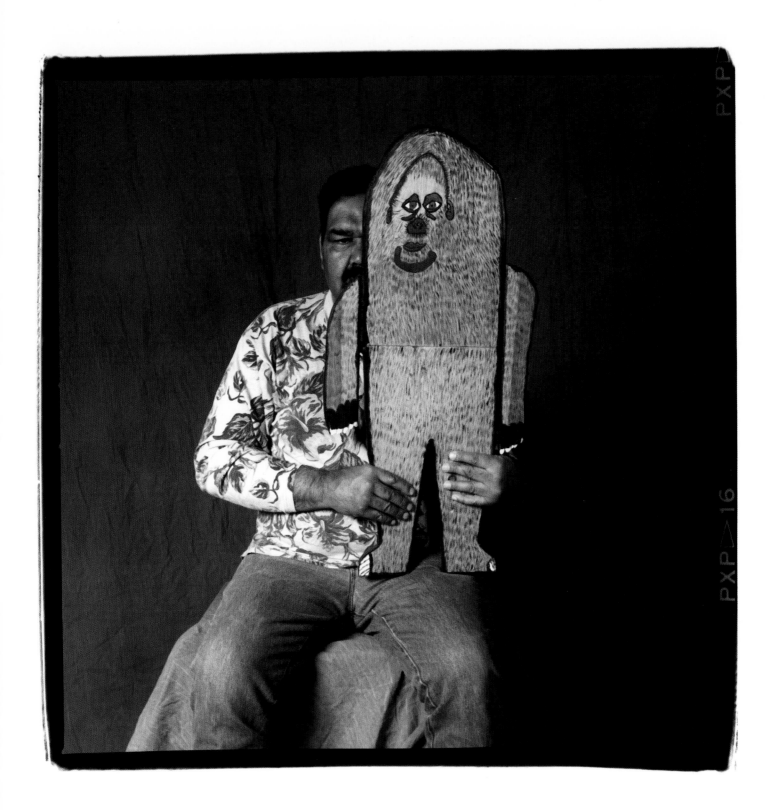

LOUIS ESTAPE

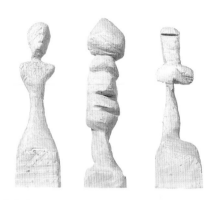

Each piece:
BALSA WOOD, 8" x 1¹/₂" x 1¹/₂"

I feel proud in my heart when I come here to Creative Growth and sit in my wheelchair and when a long handled paintbrush paint my memories of long long ago for everybody to see and know.

As I sit in my chair and reach down with my long long paintbrush, I pretend that I have extra long arms as I reach down and paint my thoughts on canvas.

I try my best to paint as perfect as I can because I feel like my paintings are my expressions and are extensions of me.

Paintings is also another way for me to communicate because I can paint what I can't say with words.

I feel so moved because when I leave this world, I want to leave something behind for people to remember me. So I'm going to keep improving my painting until I make my painting my legacy.

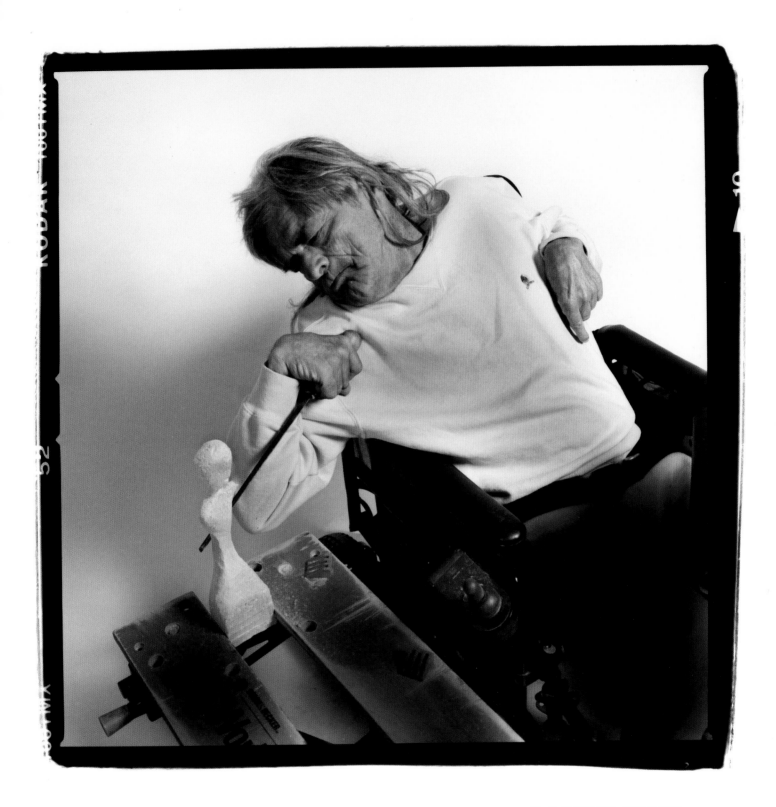

ROBERT FEISE

Sad

When people put me down
when people ask me
You don't now this or that.
 People put me down when they don't
Now nothing. Nasty people to Negative.

When I was in Elemantary school they were
Teasing me. Heare come Jackie.
I just suffered in silent.
My mother new that.

MIXED MEDIA, 24" x 18"

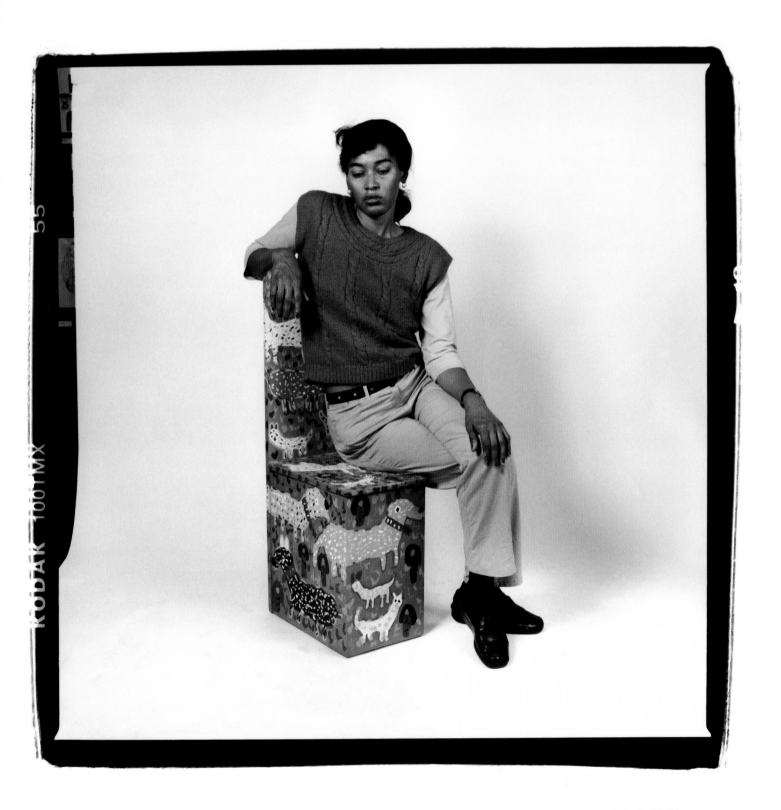

KODAK 100 TMX 55

JACQUELINE FRANK

My father took me all around to carnivals.
He took me to circus when I was a kid.
I liked the people and the rides.
I won prizes. Many prizes.
My father used to dance all the time.
He went to the carnivals and the circuses.
My father took me hunting.
I've hunted deer, birds, rabbits.
We just went hunting on and on.
We caught salmon.
I am proud to be Native American.

Wilford, Buensaw

MIXED MEDIA, 20" x 24"

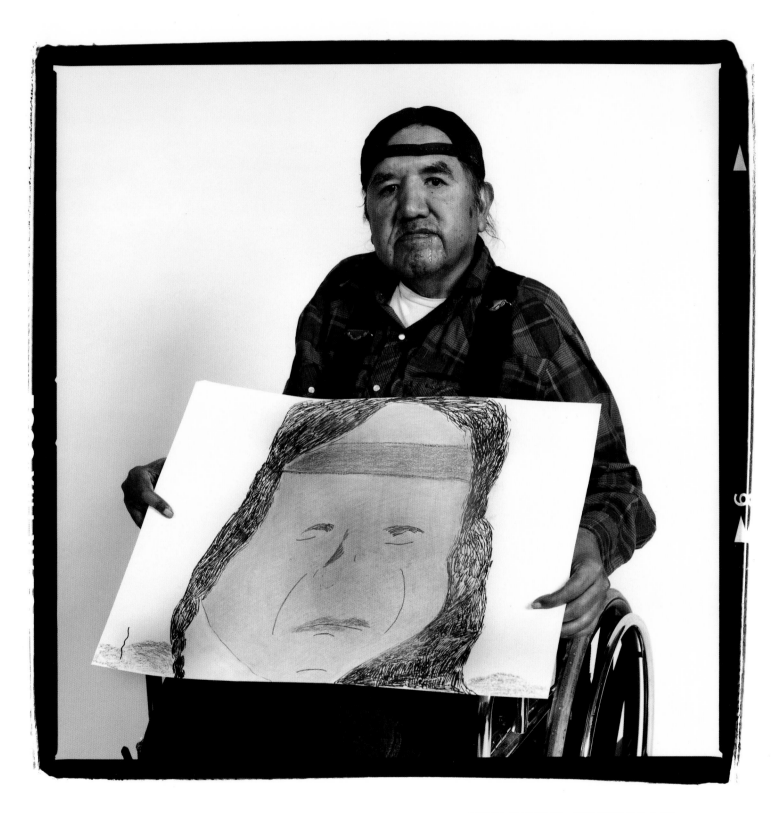

WILFORD FREEMAN

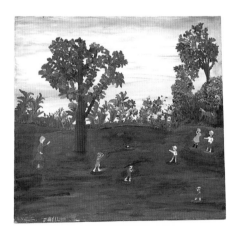

TEMPERA ON CANVAS, 30" x 31"

Growing up in Texas, Eva never saw the lush green gardens she depicted in her paintings. Although all the paintings were of the same subject matter, each rendition was individual. Blooming trees tower over gardens of colorful flowers and scampering animals. Families picnic, and children run and play ball and other games in her tranquil environments. So tiny that her feet hardly met the floor as she sat in her chair, Eva worked slowly with quiet determination, entering a world she never visited except in her imagination.

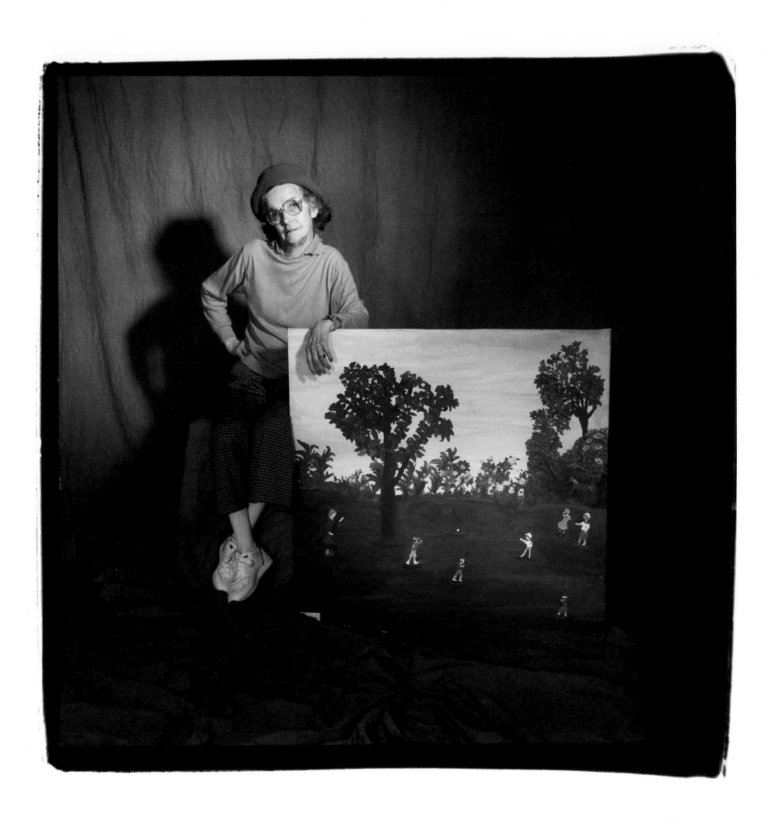

EVA GARRETT

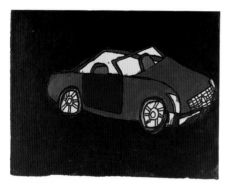

MIXED MEDIA, 8" x 10"

Although Jade is physically imposing, he is a gentle giant: placid, he rarely spoke while at Creative Growth, but when he did it was with a great sense of humor. He also changed the color of his hair on a bi-weekly basis.

He was a very deliberate draftsman; he attempted some landscapes, but his passion for cars took over. His obsessive love of low-rider and muscle cars is reflected in his art, in a palette limited to black and blue, colors he favored in his own dress. It seemed as if Jade's love of power and speed compensated for the limitations of his own body.

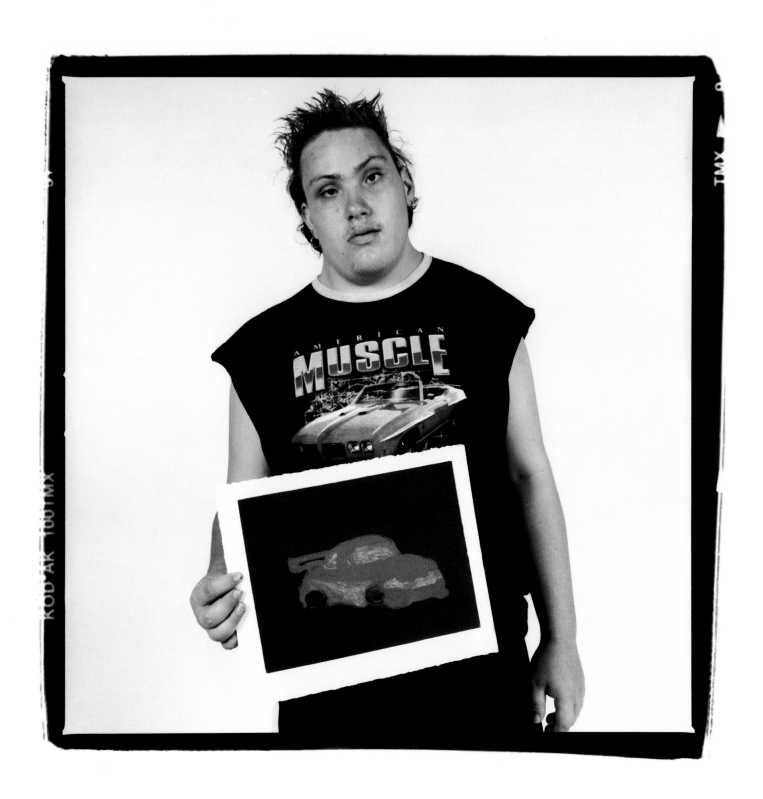

JADE GONZALES

Gloria. Gonzalez.

I like rockets because
theye fly on the sky
rockets fly up the spase
to another planet

I com from spanish place
Nicaragua
I wos 8 years old
we come hier because
it wos war there
killieng it othere

PRISMACOLOR MARKER, 30" x 22"

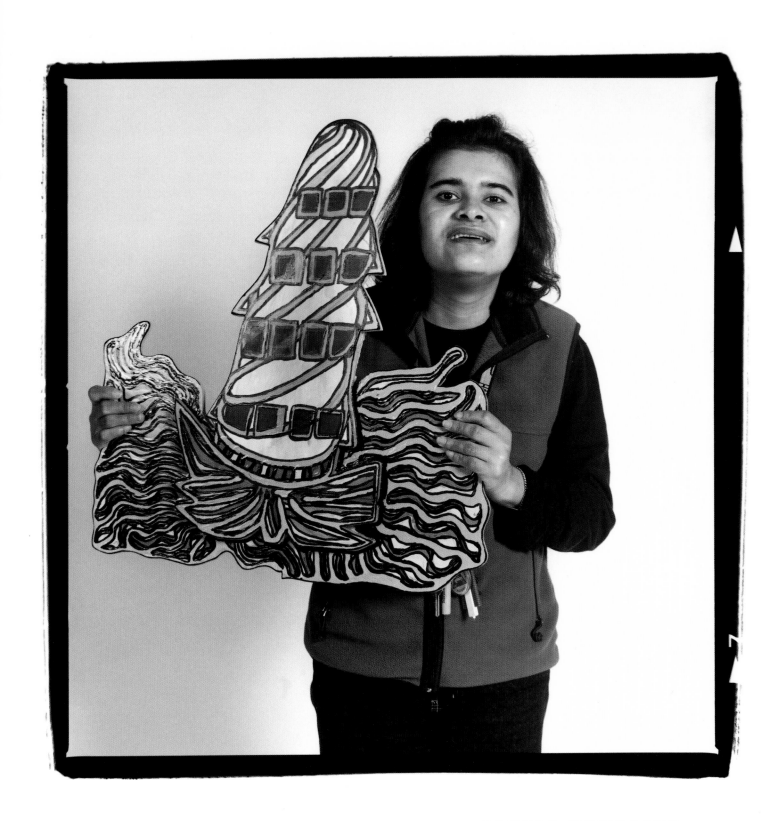

GLORIA GONZALEZ

PRISMACOLOR PENCIL AND MARKER, 24" x 18"

The Creative Growth gallery once featured "Eleanor's Garden," a room covered with her floral drawings and paintings on walls and easels. Eleanor, seated in a wicker garden chair, greeted visitors. She loved that day.

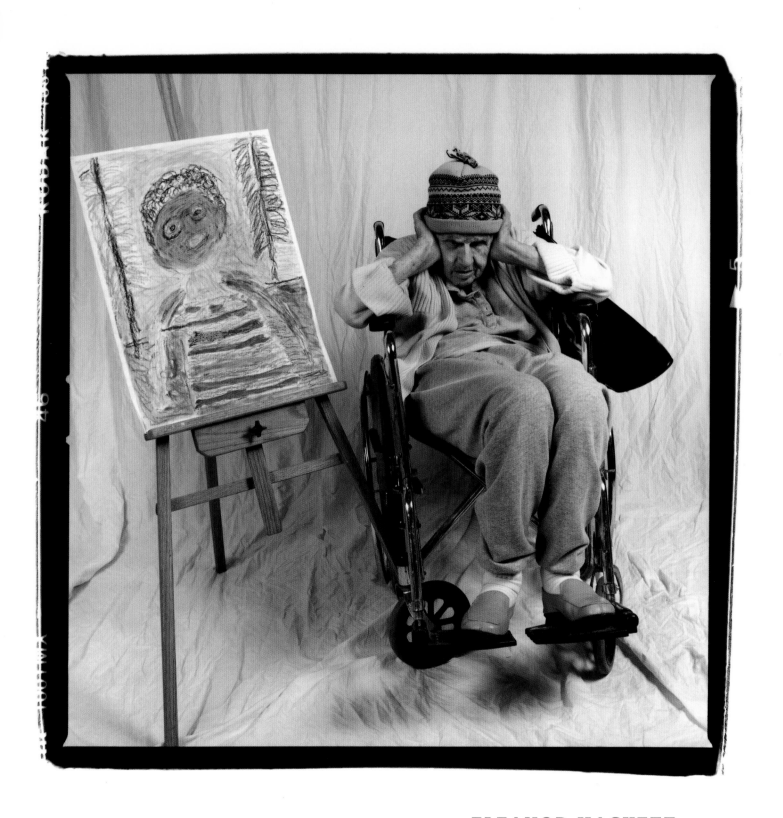

ELEANOR HACKETT

Although Carl is non-verbal, he communicates very well with gestures and body language. He is persistent, focused, self-directed, and industrious. He scavenges the wood shop for cut-off lumber and, through a repertoire of gestures, communicates to Creative Growth volunteers where pieces should be sawn. He uses no measuring tools, yet restricts the dimensions of his chairlike structures to the physical size of his body.

After 2 or 3 years of perseverance on this project, Carl unlatched his safety belt and sat in his Bauhaus box smiling, as he moved it slowly through the studio on small steel wheels.

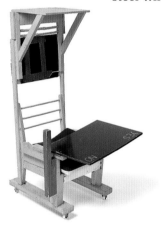

WOOD, 55" x 22" x 31"

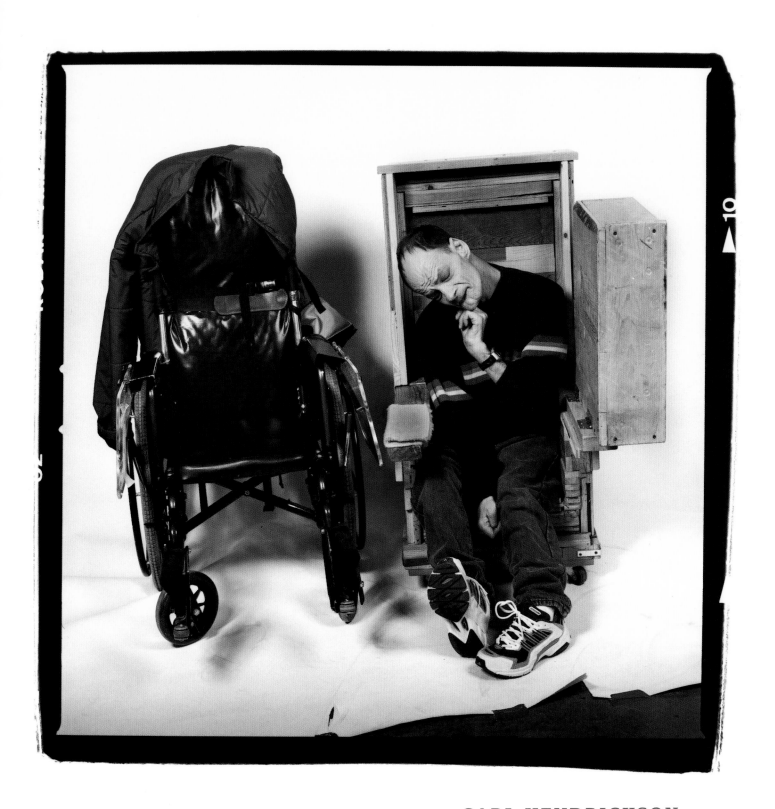

CARL HENDRICKSON

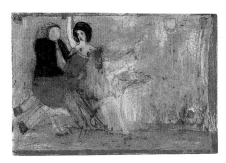

MIXED MEDIA, 12" x 18"

Suzan died of heart complications in 2002. She had many friends and was surrounded by a loving, supportive family. She used a respirator, but that never stopped her from doing her artwork or falling in love. She worked hard on her ceramic work, making whimsical drawings on plates she made herself. Her imagery was limited to childlike drawings and simple motifs.

She was very religious, and her work, including many drawings of angels, reflected this spiritual belief.

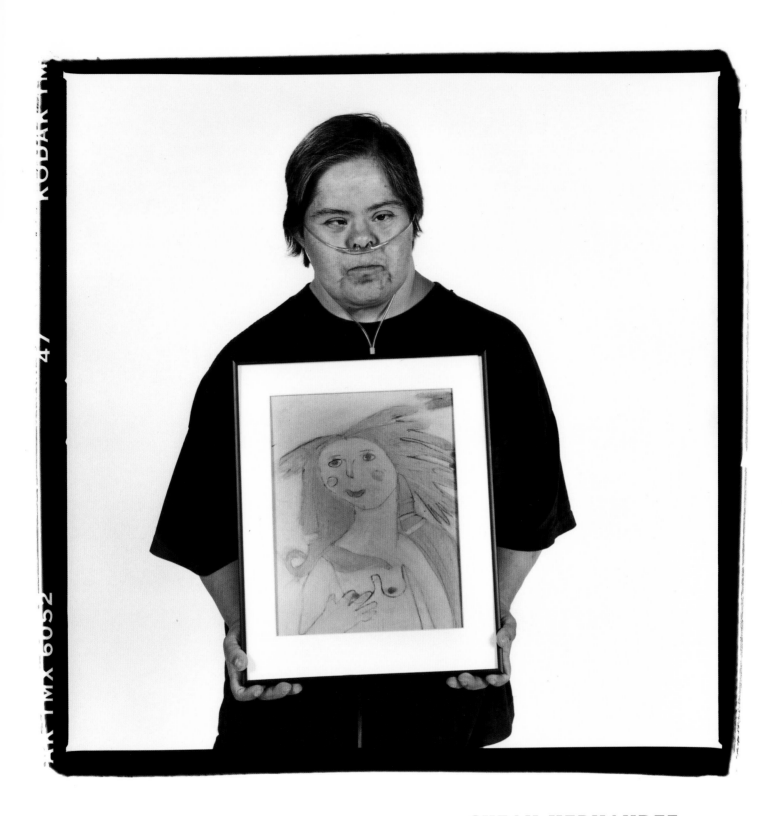

SUZAN HERNANDEZ

OIL PASTEL, 22" x 30"

Camille's life is driven by control, her work borne from the monumental fear of losing it. Her candy-colored pastel drawings evoke a cinematic dream-like state where powerful desires and appetites find magnified expression.

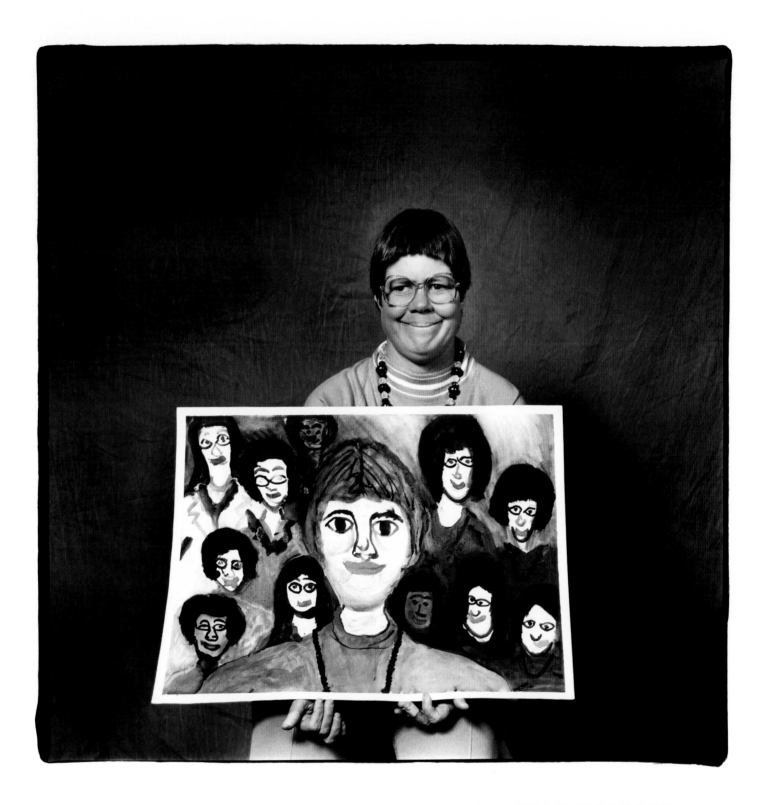

CAMILLE HOLVOET

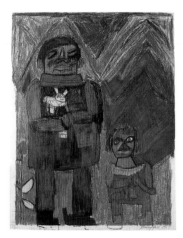

MIXED MEDIA, 18" x 12"

While attending Creative Growth, Shirley loved fiber arts and the opportunity to share her Chinese heritage in two- and three-dimensional works, like Buddhist temples of bamboo and parchment, paintings on silk, and hand-painted kimonos.

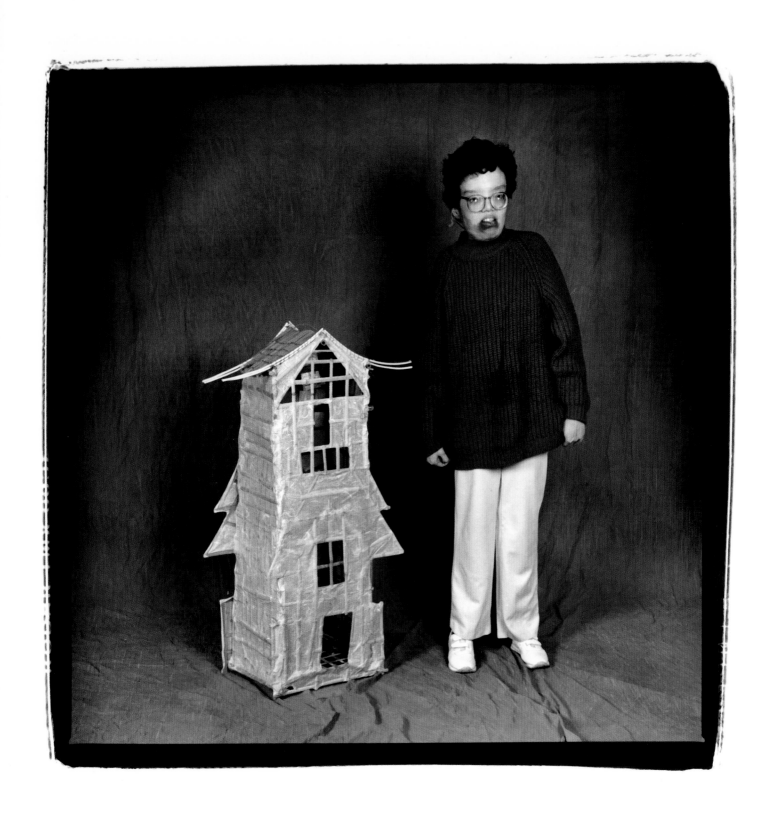

SHIRLEY HOW

I am coming to the Center because I never wanted to give up. I had two brothers that were trying to discourage me, but I didn't give up. I never did find out why. I never did. They still live in Oakland. They treated me like dirt. I am not missing them. The only thing I am missing is the schnauzer. I was Ialking to him and he keep I still remember him. He was a small little dog.

When I came home he was barking words. Congratalations."
He was a person.
He liked ne.
He was barking nice words at me.
They took dog away.

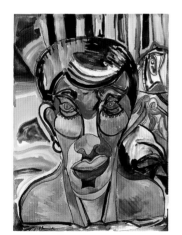

MIXED MEDIA, 24" x 18"

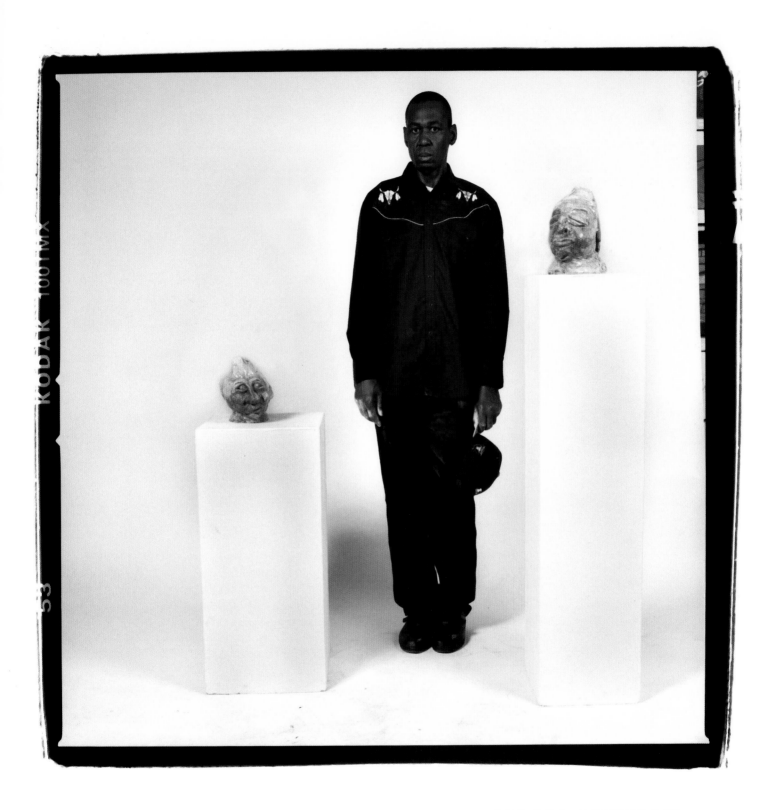

CEDRIC JOHNSON

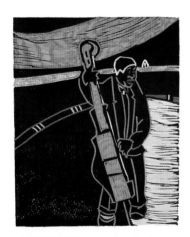

LINOCUT PRINT ON PAPER, 10" x 8"

George Kellogg was a master of all artistic media. Drawings, paintings, sculpture, hooked rugs, and prints all bore the stamp of this versatile artist. Hospitalized for many years with mental illness, he never quite exorcised his private demons. They emerged in his art, where he faced them and sought refuge from his fears. He was a sophisticated, well-read man, and had attended many art classes before coming to Creative Growth where he found friends and an artistic home. His stunning black-and-white print portfolios of American jazz greats were purchased by the city of Oakland and presented to diplomats from countries with consulates in San Francisco.

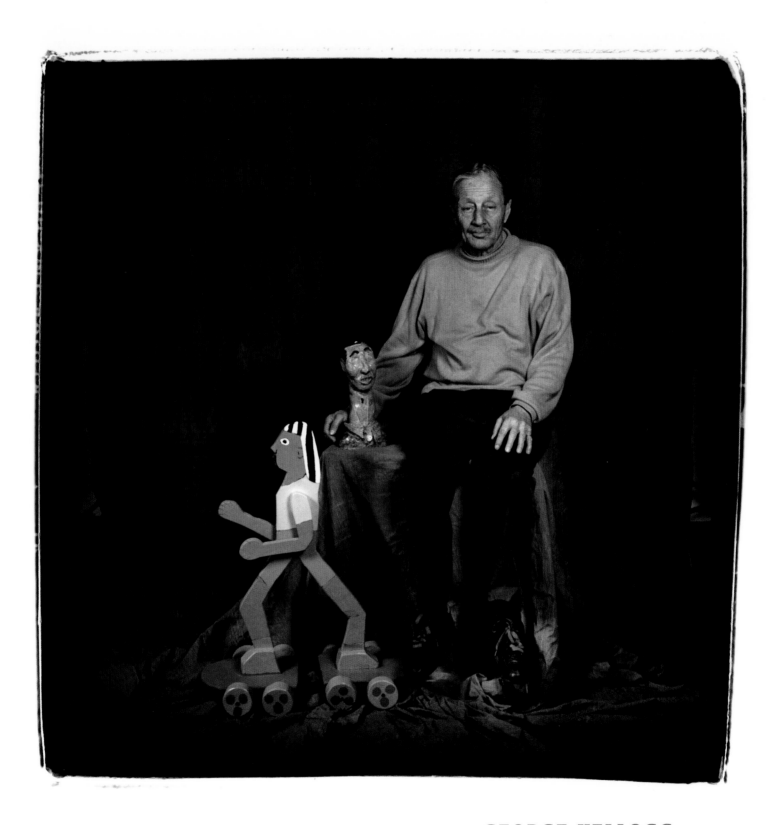

GEORGE KELLOGG

I have brother timmy
He is odd I have sister
I dont renember
my family

Allan
Lofberg

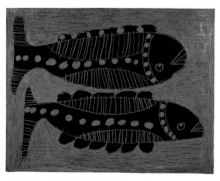

LINOCUT PRINT ON PAPER, 11" x 14"

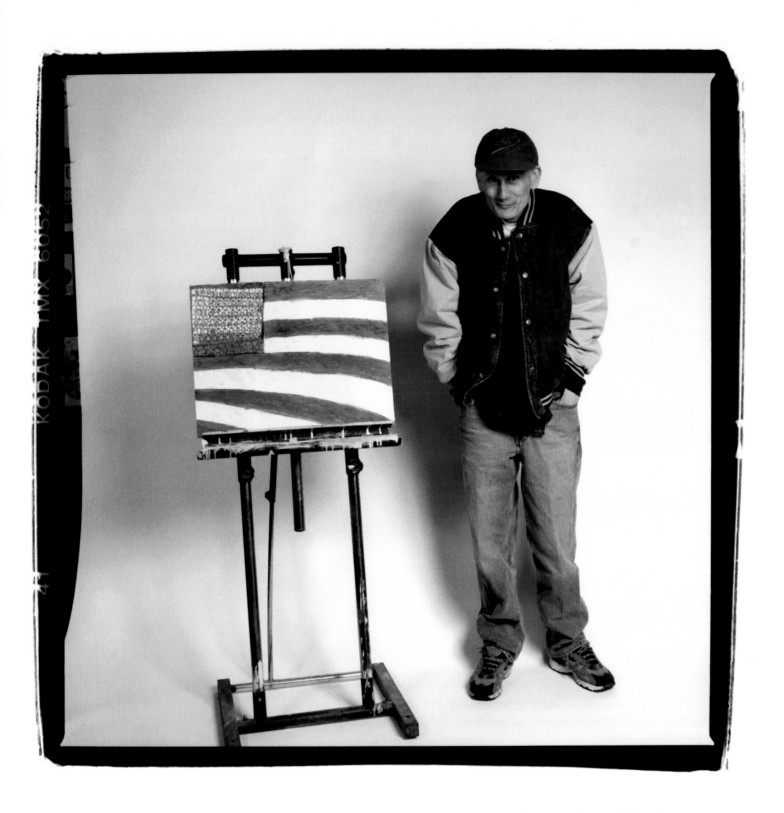

ALLAN LOFBERG

Dwight Mackintosh's work, chronicled in art historian John MacGregor's book *The Boy Who Time Forgot,* featured erotic androgynous figures, turn-of-the-century vehicles, and Picasso-like beasts. His artwork, primarily drawings done in bold slashing black pen, propelled him out of the boundaries of Outsider art and into the elite world of museums and galleries.

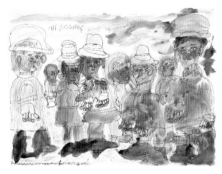

PERMANENT MARKER AND WATERCOLOR, 22" x 30"

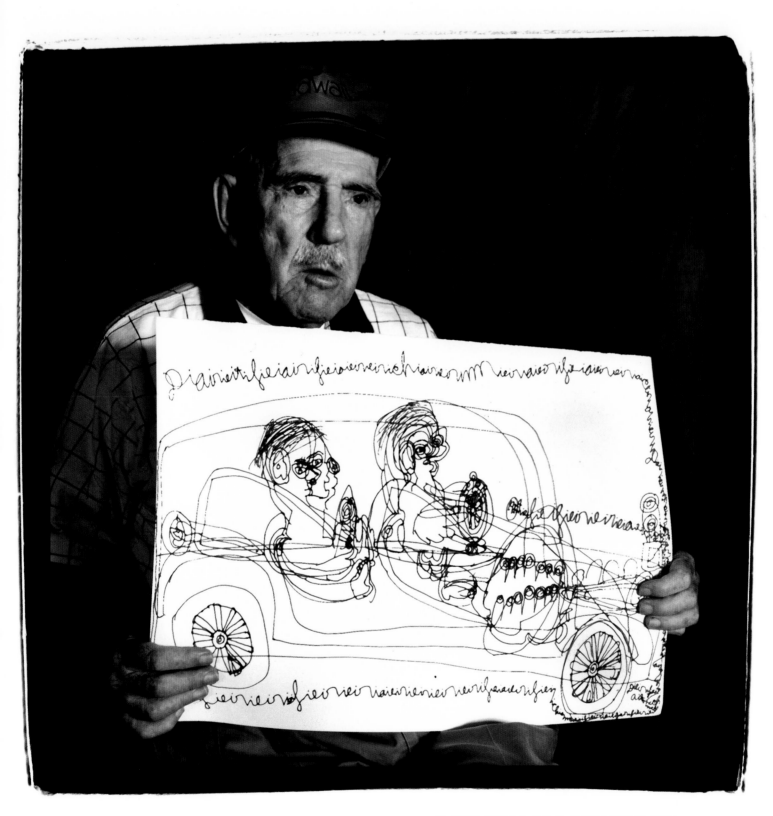

DWIGHT MACKINTOSH

This is a quick sketch from a photo of Orthodox Jewish men. I'm learning to draw.

Some years ago, I read about the Baal Shem Tov, who ecstatically danced and sang his way to God, and I got interested in Chasidism. I, too, wanted to dance and sing my way to God. So I went to talk to a local Lubavitcher rabbi, a nice guy. I asked, among other questions, "Rabbi, what do you think about homosexuality?" Homosexuality is, he said, a sin for men and not recommended for women. The funny thing was, it was Purim, the holiday of irreverence in which costumes are worn and crossdressing allowed. There I sat, being lectured on the evils of homosexuality by a rabbi wearing his wife's shaytel (wig) and a clown costume!

I didn't last long with the Chasidim. They kept trying to marry me off, and not to another woman. I had to look elsewhere for ecstasy.

Chava Malka

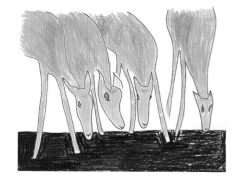

PEN AND OIL PASTEL, 6" x 9"

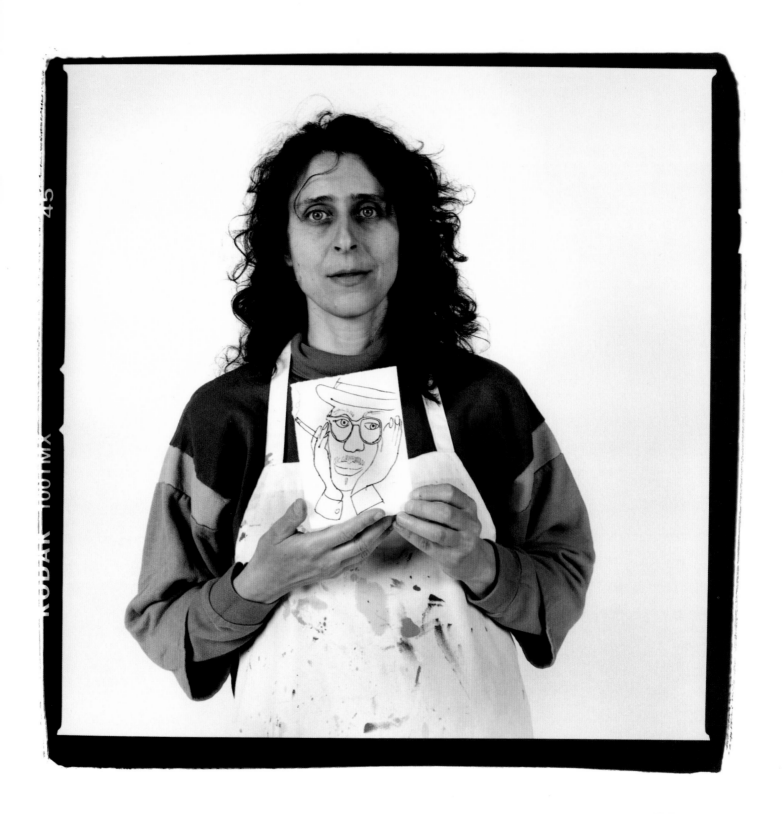

CHAVA MALKA

I guess tomorrow is Christmas. I am celebrating it with
my aunt. Celebrating my own Christmas.

I go to church a lot. Actually I went a lot when my mother
died with cancer. I felt bad about. Yeah, my mother keep
dying with cancer. I hate that.

She died with cancer. I cried a lot. I felt bad. I lost my sis-
ter and I lost my mother. My sister has cancer, too. So that
makes, that left me behind.

I can't do anything about. This is God's work.
God takes what he want take.
Can you do something about?
When God is ready for you, that is.
You can't do a thing about.

JOHN MARTIN:

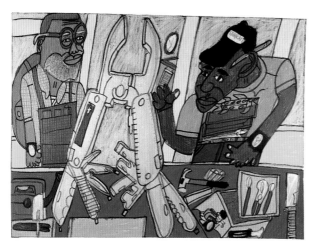

PRISMACOLOR PENCIL 22" x 30"

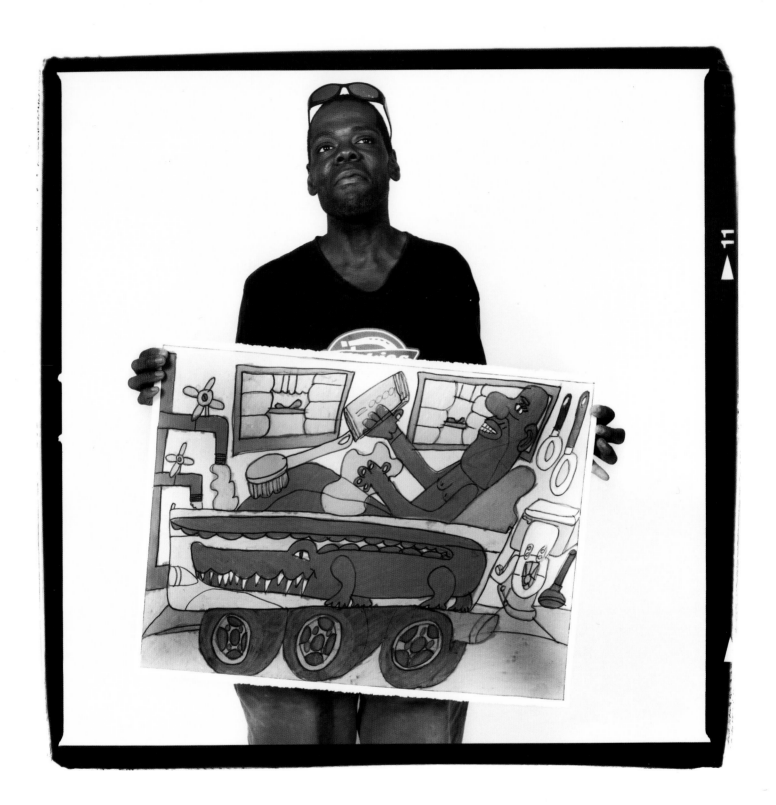

JOHN MARTIN

Danny MILLER

BLOCK ON OFF
LUMBER CIRCLE GARETTOR

SHOPI
ROTER CIRCLE SWITCH
WALL BLOCK CLICK!
CEILING ON OFF
PUSH
BACK FLOWER FLOOR GATE
LIGHT CAT BRIDGE CAT
MOUSE DOG

MIXED MEDIA, 16" x 24"

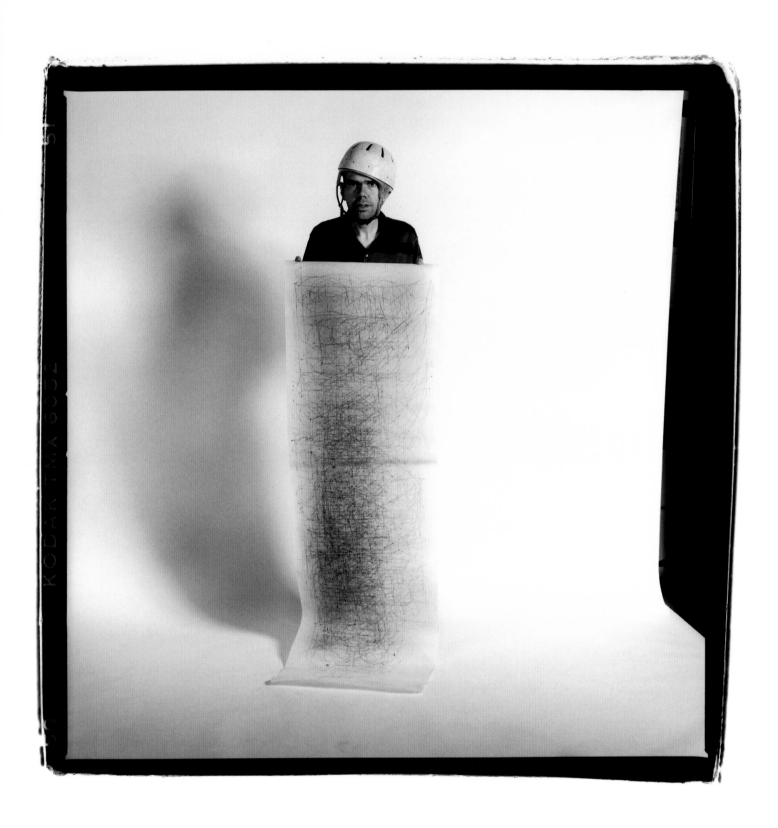

DANIEL MILLER

Can you write something for me?

Yes.

What is that?

This are people. All people are me.

What is that?

Boxes. Boxes are house.
This is my house. I live there. Here.
Suzan lives downstairs.

Donald Mitchell

PERMANENT MARKER AND WATERCOLOR, 30" x 22"

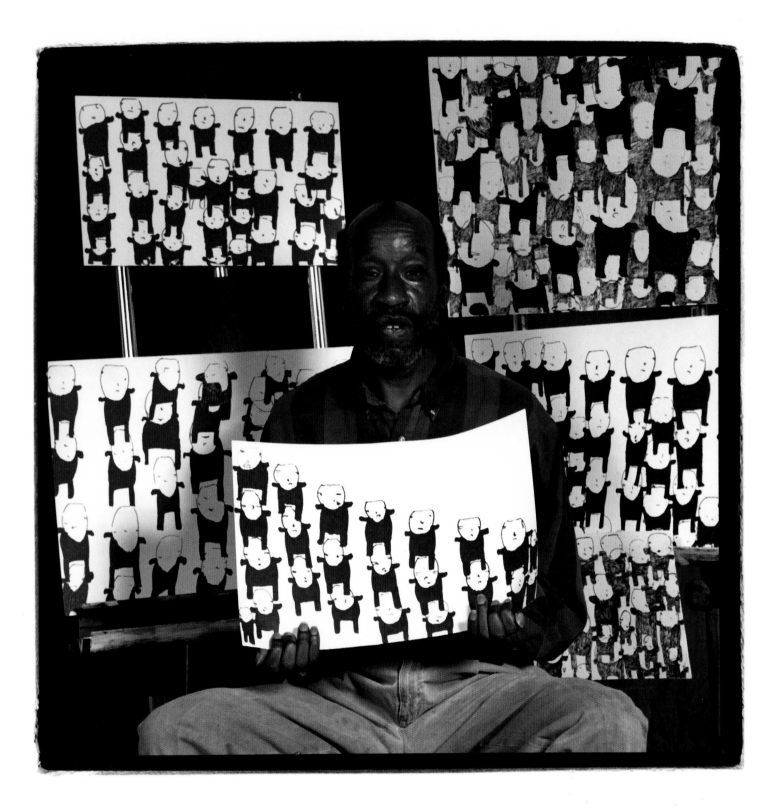

DONALD MITCHELL

NOTHING
MAKES ME
MAD
I JUST DO IT
OVER OVER
AND
I MAY FEEL
MAD INSIDE
BUT THAT HOW
I LET IT OUT
OF ME
I LIKE ART
YES
OVER OVER
AND OVER
AGAIN

CHARLES
NAGLE

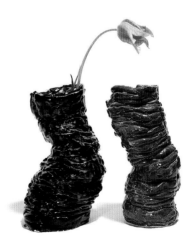

CERAMIC, 18" x 4"

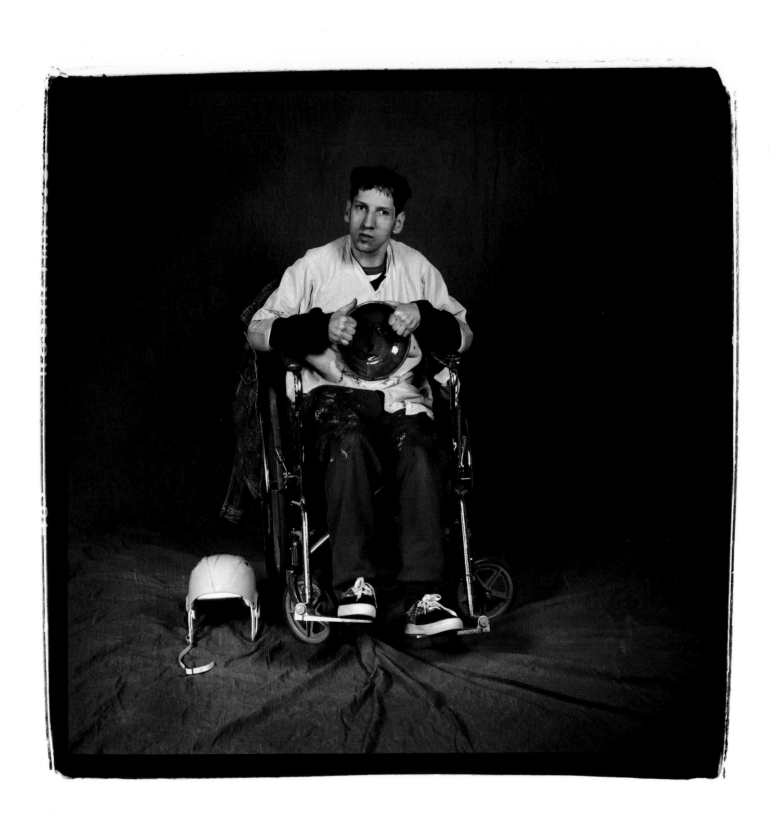

CHARLES NAGLE

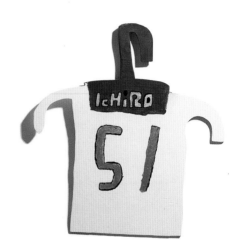

LATEX PAINT ON WOOD, 24" x 20" x ½"

I was two years old when I was adopted. My adopted parents told me that I was very happy to be adopted. I didn't like to be there. I never met my mother, she lives in Tokyo, Japan and I don't have money to go there to look for her. It makes me very sad.

I hope one day to fly Tokyo to look for her. It is very hard, but I am happy that you are asking me all the questions and writing down my answers.

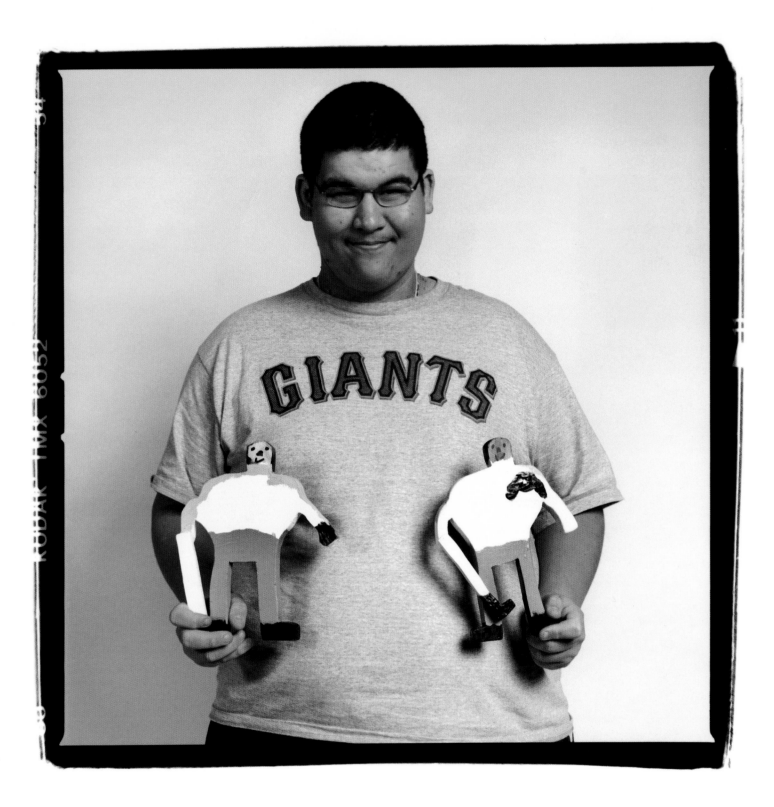

BRIAN NAKAHARA

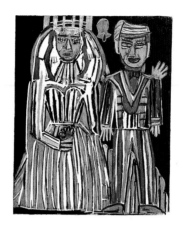

LINOCUT PRINT ON PAPER, 10" x 8"

At Creative Growth, Donald observed the popular icons of culture and translated them in a truly unique way. In Donald's colorful world, his personal alter ego Elvis often appears along with King Tut, cats, birds, vampires, pink Cadillacs, California palms, cacti, skyscrapers, and pyramids. Donald was very prolific, working in almost all media, and learned quickly through direct observation. Although he suffered a severe speech deficit, Donald was able to communicate his singular vision through his art.

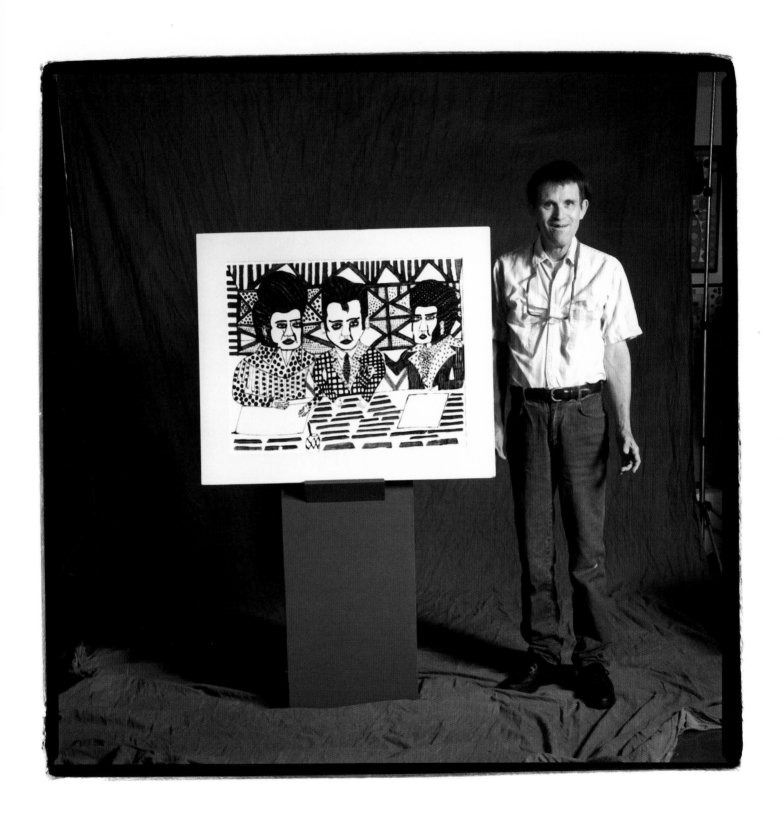

DONALD PATERSON

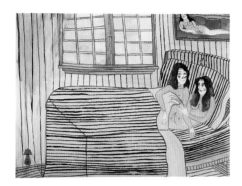

PERMANENT MARKER AND WATERCOLOR, 22" x 30"

No one puts together an outfit like Aurie, dramatically conspicuous with her makeup inspired by the rock band KISS. Yet she speaks in hushed tones, whispering streams of indecipherable syllables with an occasional recognizable word rising above the barriers erected by autism. Her bizarre, delicately rendered watercolor and ink compositions depict a world of interiors evocative of sumptuous nineteenth-century salons and bedrooms, where bow-tied dandies and petticoated ladies of leisure conduct their sexual activities, in full clown make-up, with a level of decorum and nonchalance fit for an afternoon tea party. The striped wallpaper, matching sheets set, and corner nightlight inspire more ardor.

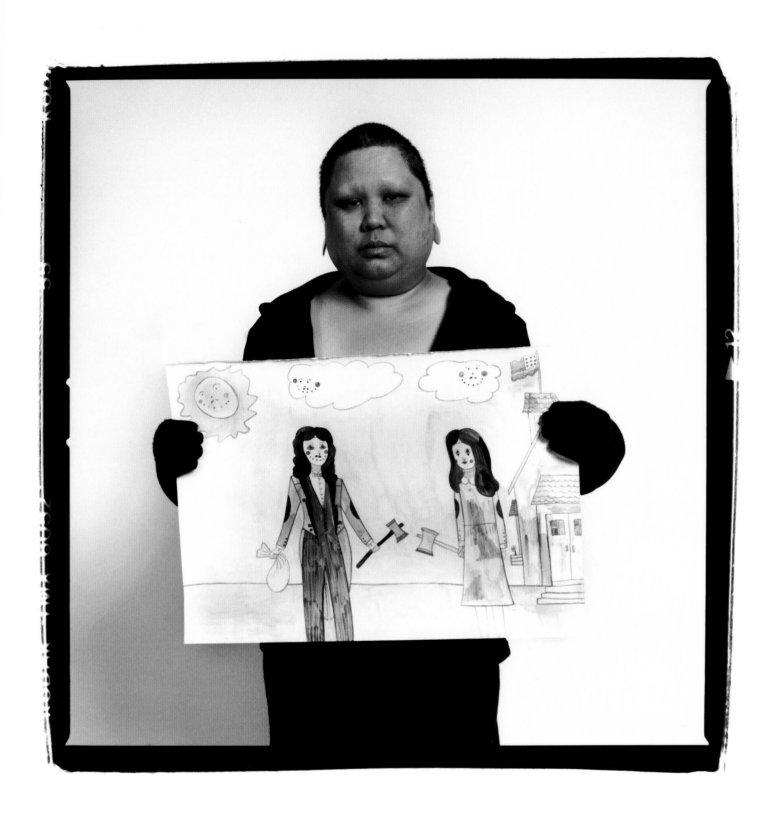

AURIE RAMIREZ

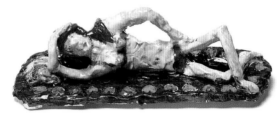

CERAMIC, 9" x 5"

I get inspired by my dreams and nightmares mostly. I try to put my feellings down into my Art. My Art often relaxes me. I get frustrated when I can't make it like I want it. I just keep trying.

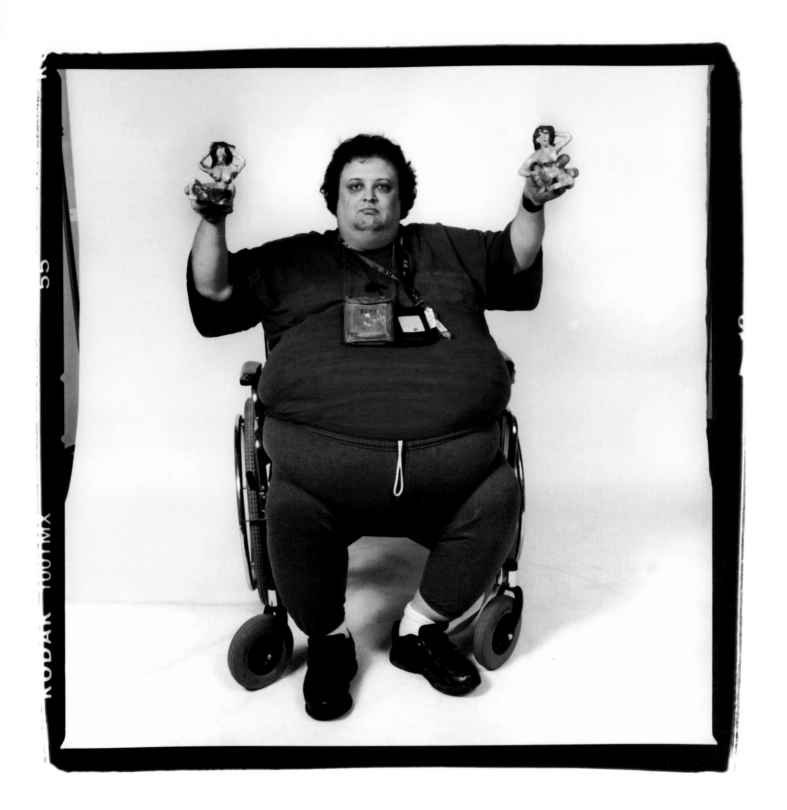

STANLEY REXWINKLE

ACRYLIC PAINT, 22" x 30"

When I look at my portrait I get a little dramatic.

I am trying to make something and sometimes it doesn't happen, but when it does I get my point across.

I would like to do ceramics. But really I can't do it except for the ideas, but I can paint.
I can move paint better.

I can't move my physical body, but I can move paint.

Diane Rhodes

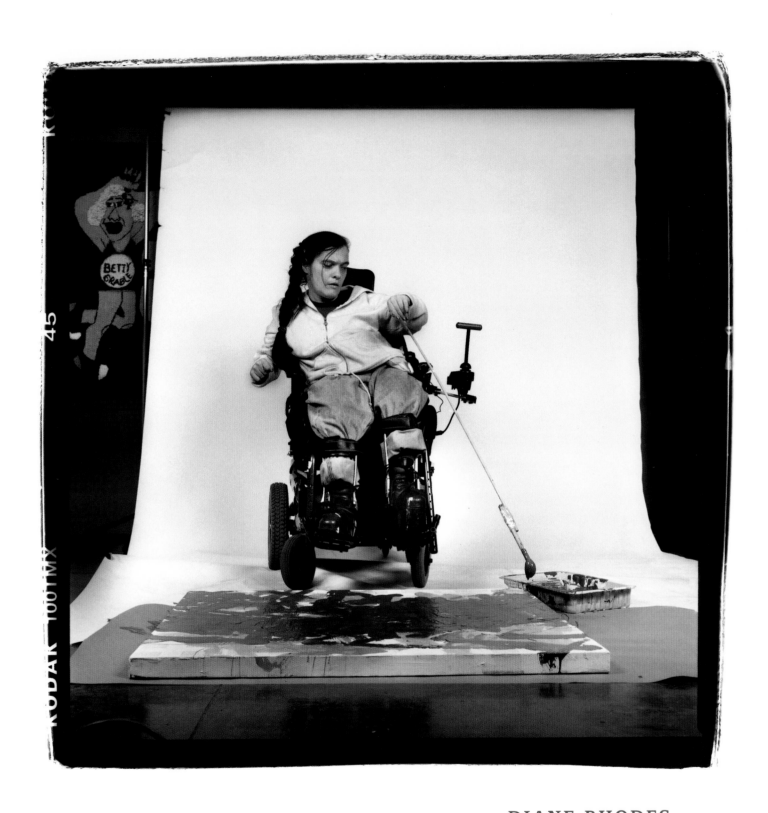

DIANE RHODES

ADAM NCiHELAOSEZEiK KiLL ROMERO
1975 ARiZON AND 1976 SF
MAY 28
SPiED-MAN
ONE iS ADAM
ONE iS SUPERMAN

Who are these guys?
Me!

Who are they?
One is Superman and one is Adam.

Do people know it's you when they see you flying around?
Yes.
I like coming to this class
and I like my best friend David.
I can't tell you what we are talking about.
That's top secret.

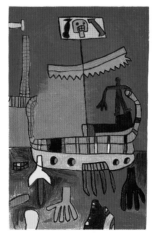

PRISMACOLOR PENCIL, 18" x 12"

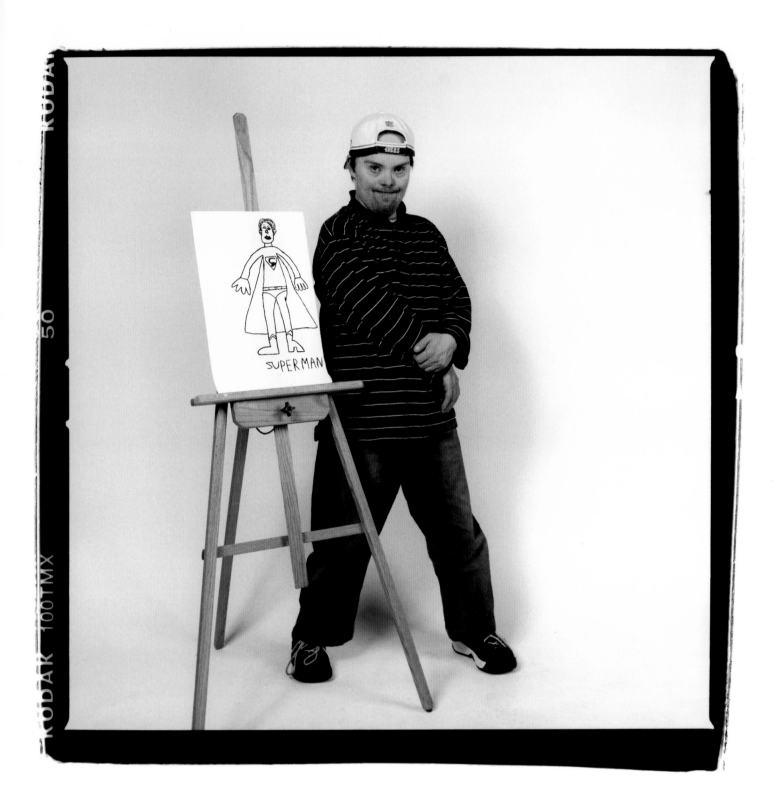

ADAM ROMERO

I like clay
I can feel it
+ watch the piece
take shape
In Clay I con-
centrate so
hard I lose
myself.

In my wheelchair,
I drive fast
I fly free
I take risks
I feel joy

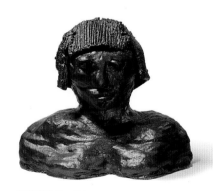

CERAMIC, 2" x 1½"

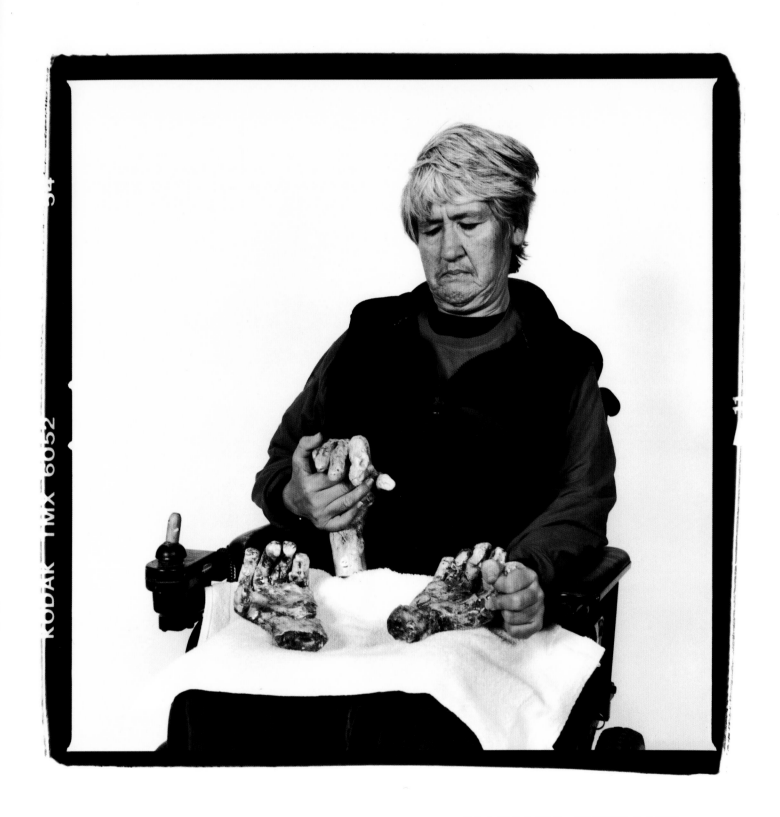

MARIANA RUYBALID

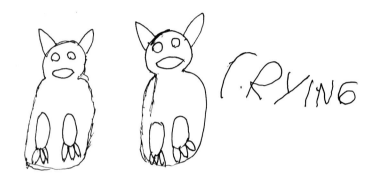

CRYING

MY NAME IS FEYCHANSAEPHAN

IAM FROM LAOS

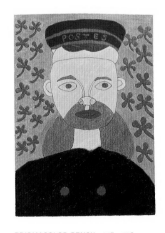

PRISMACOLOR PENCIL, 18" x 12"

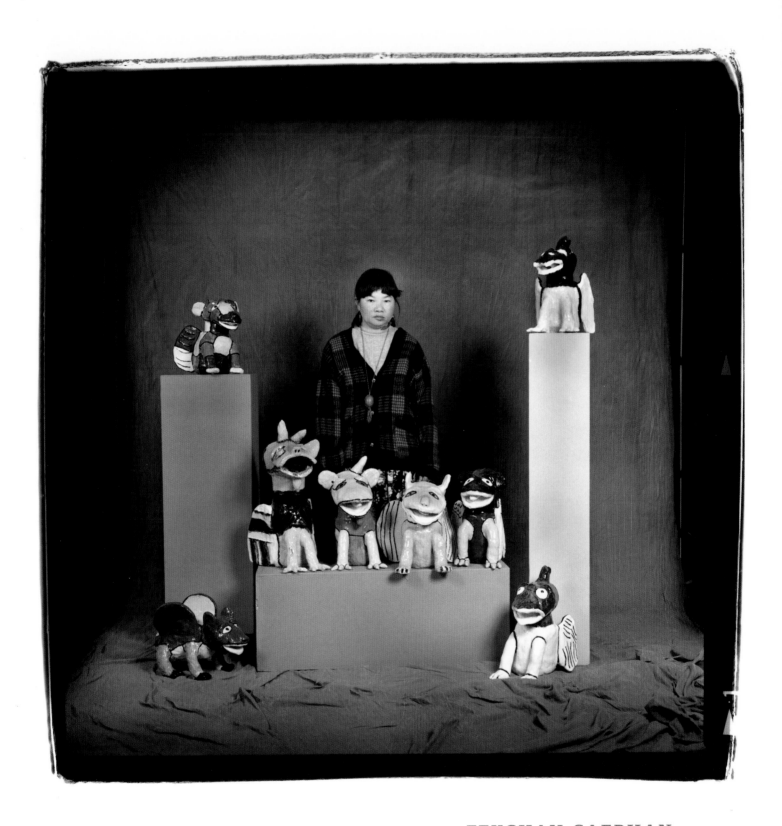

FEYCHAN SAEPHAN

About Judy: She seems to me truly the better half of our twin-ness. I look to her for inspiration in all parts of my life—her integrity, her determination, her incredible creativity and dedication to her work. In her art and in her life, I see her celebrating the joy of being alive, blending all her loss and suffering into piece after piece of sculpture of incredible beauty.

Judy likes to wear at least one colorful headscarf, sometimes more, always carefully wrapped. She wraps her head like one of her sculptures, an artist always and in all ways. I think she likes to create her art more than anything, and after that, to be with me, but always, she makes it clear, she likes her privacy.

I love that she doesn't care what other people think of her, good or bad, that she won't be influenced by outside voices, and I suspect it's a great help that she's never been able to hear them.

Judy has a vision and she has focus and integrity, those traits we all aspire to, and fear we may have wandered from. She leads me back.

She inspires me.

She inspires others.

—Joyce Scott, Judith's twin

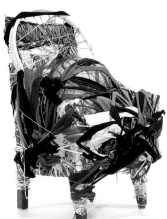

MIXED MEDIA, 30" x 18" x 18"

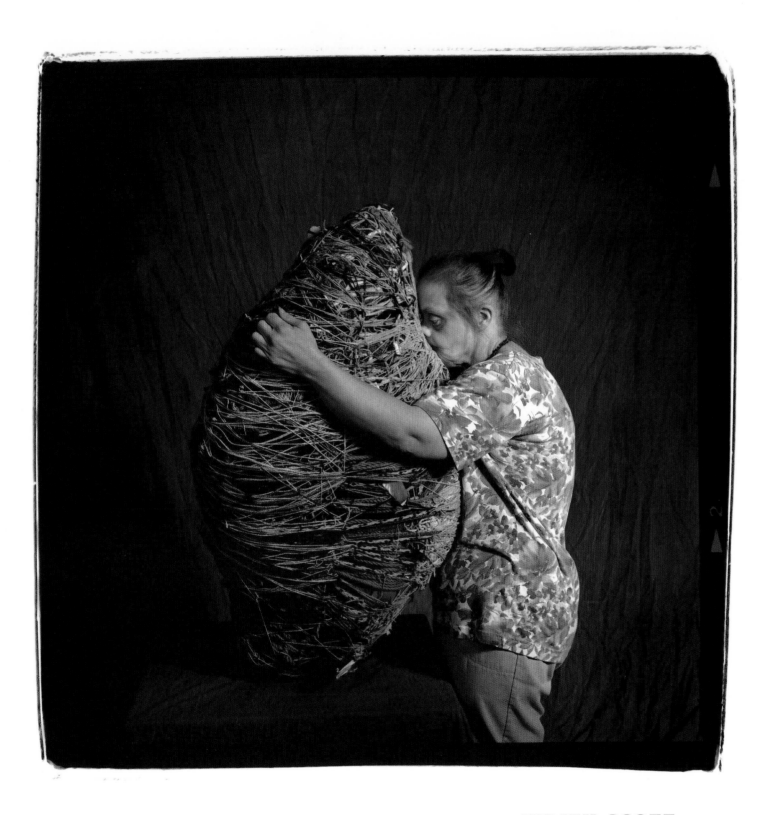

JUDITH SCOTT

William Scott BECOMES A PRAISE DANCER TO BE DANCING FOR THE LORD TO BE KEEP HIM TO BE DOING THE RIGHT THENGS TO BECOME A GOOD LESSIONS TO BE TREATING PEOPLE RIGHT TO BE MAKING FRIENDS TO PEOPLE EVERY WHERE. WILLIAM SCOTT IS GOOD HE WANTED TO BE A TOLERENT MAN TO BE STAYING GOOD HABITS TO BE STAY OFF BAD HABITS UNTIL HE WILL BE BORN AGAIN AS A PRAISE DANCER AND BASKETBALL PLAYER IN THE 1970'S IN THE ANOTHER LIFE

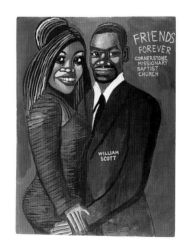

ACRYLIC PAINT, 24" x 18"

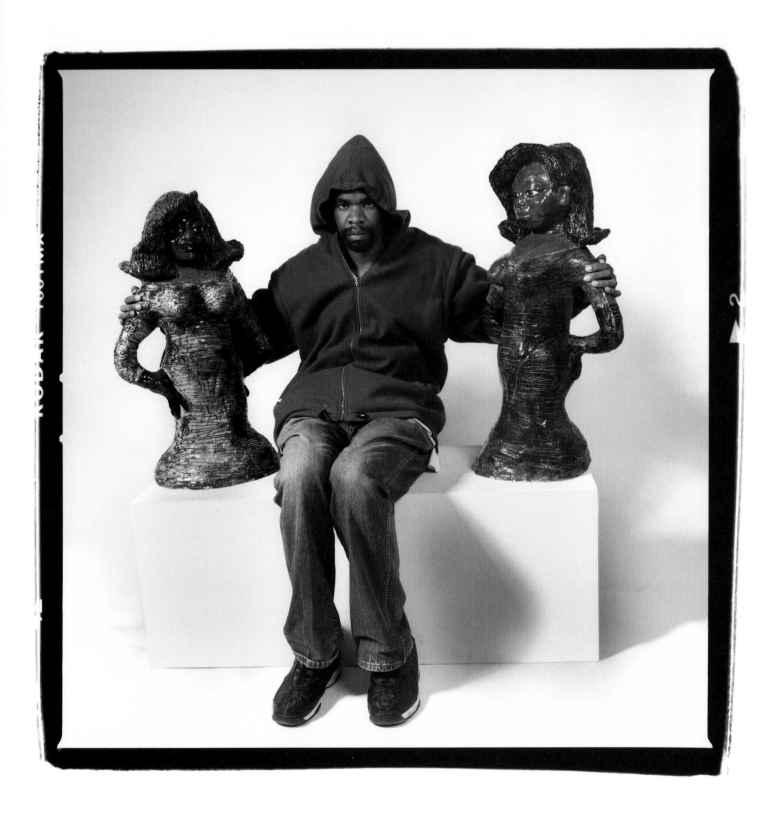

WILLIAM SCOTT

I'm 40 years old.
When we meet we became friend when
I was 22 years old. Only since I 12 years ago.
When I was 28 years old.

We are allowed to be in class
Together.
We are special couple.

We not going out we saving for
our future place place together.

When honey I come
Together
We glow

We glow together.
Special feeling not
Dirty.
We our pure love
Clean as Cat and Dog.
Dinah Shapiro

I LOVE honey
you with all my
heart

Ernest Spears

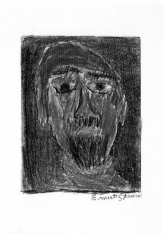

ERNEST: OIL PASTEL, 24" x 8"

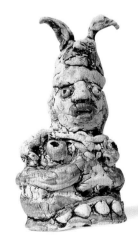

DINAH: CERAMICS, 10" x 6" x 5"

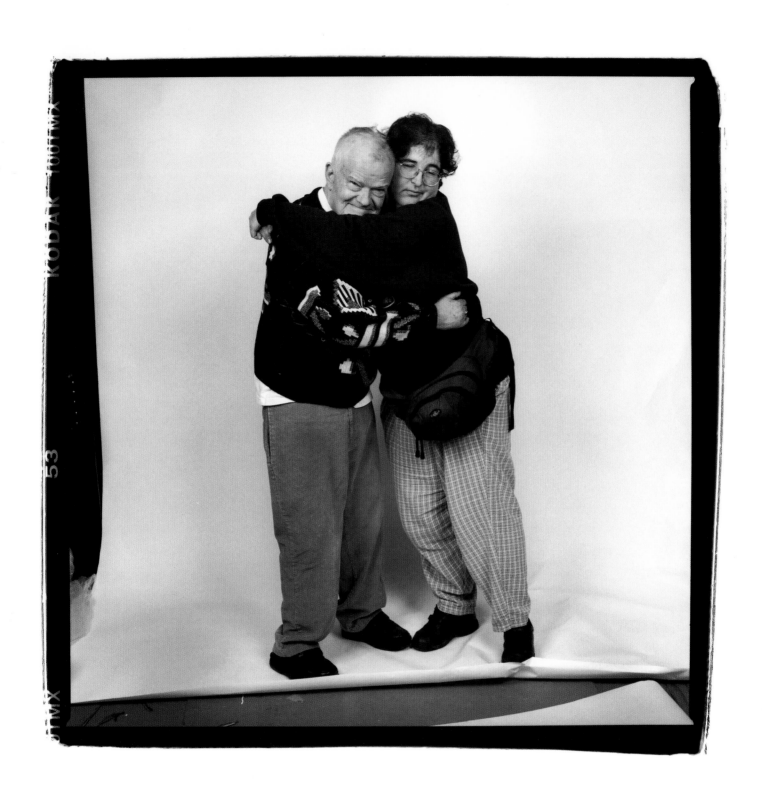

ERNEST SPEARS/DINAH SHAPIRO

WATERCOLOR, 5" x 5"

Sharon was a trained artist before she became disabled; she ran an art gallery in Southern California and designed and made jewelry. Confined to a wheelchair with only very minimal use of her hands, Sharon drew and painted with a stick in her mouth, or wore a headpiece to which a pencil or brush could be attached. She never revealed the enormous frustration she must have felt when her active life as an artist became so drastically curtailed. Moving her head slowly and ever so softly, her pencil and brush produced tiny delicate watercolors, often of studio scenes, that captured her fellow artists at work. Her gentle example in the face of great adversity inspired artists and staff alike.

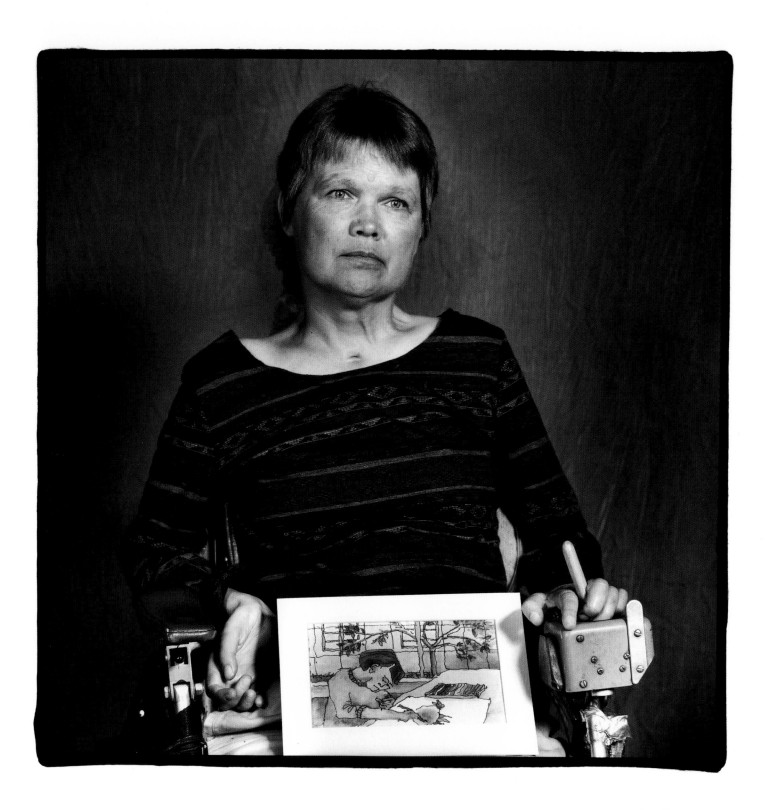

SHARON SPENCER

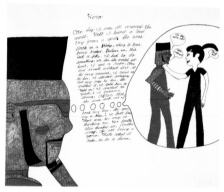

MIXED MEDIA, 22" x 30"

TEXT READS: One day I was all around the world. Until I heard a loud cry from a girl. She was stuck on a bridge, where it was being broked. Believe me, this isn't a joke. I had to do something, or she would get hurt. I got a rope, clean and smooth without dirt. At the very moment, I came up to her. I started swinging out my rope to her. She grabbed it, I told her to "Hold On," I started to pull, and I became strong. After that, she was safe and I took my time. She gave me a kiss, and I felt fine. That was her way of thanking me. Her family also thanked me. Another way, of not being a zero. That's what it take, to be a hero.

1. The pictures I created make me feel great.
2. Fablous & Excellent.
3. Cool.
4. My characters always have high-top fades. They also represent classic hip-hop & R&B from the late 80's.
5. I like drawing with colored pencils

I feel Happy. Without it, I wouldn't be able to work hard, to get where I am today.

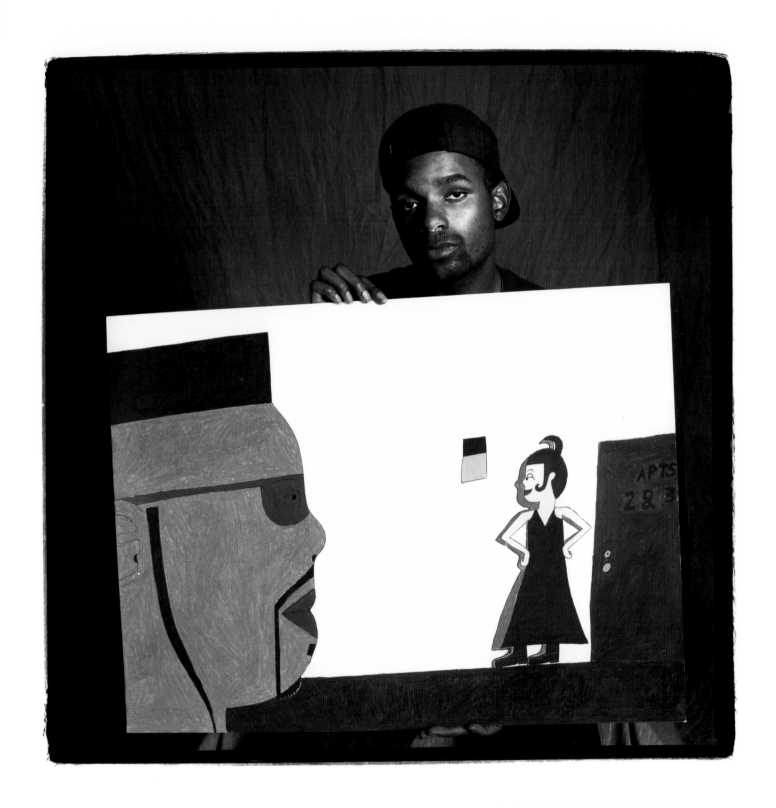

GERONE SPRUILL

I enjoy
creative growth
sometimes
I draw
houses and or
trees but
sometimes
I copy
photograph
of other
things
im gregory stoper

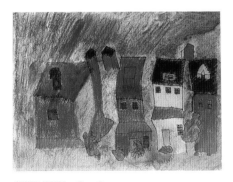

MIXED MEDIA, 10" x 12"

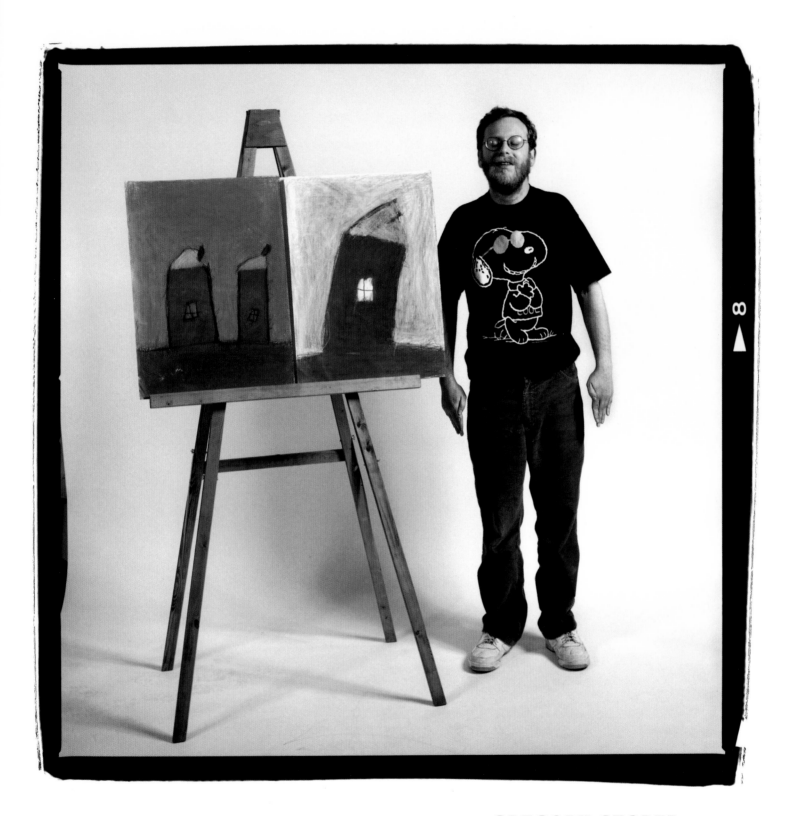

GREGORY STOPER

Twin Brother
Live in some room
Go to movies together
Peter Pan,
Magic gone

 RICHARD TYLER

I like picture about William and Richard
I like art work
I holding a picture about William and Richard
and vase

 William Tyler

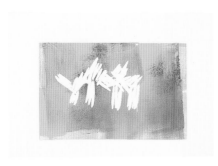

RICHARD: PRISMACOLOR PENCIL, 8" x 10"

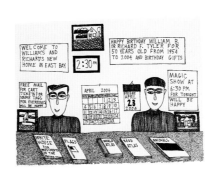

WILLIAM: PERMANENT MARKER ON PAPER, 14" x 18"

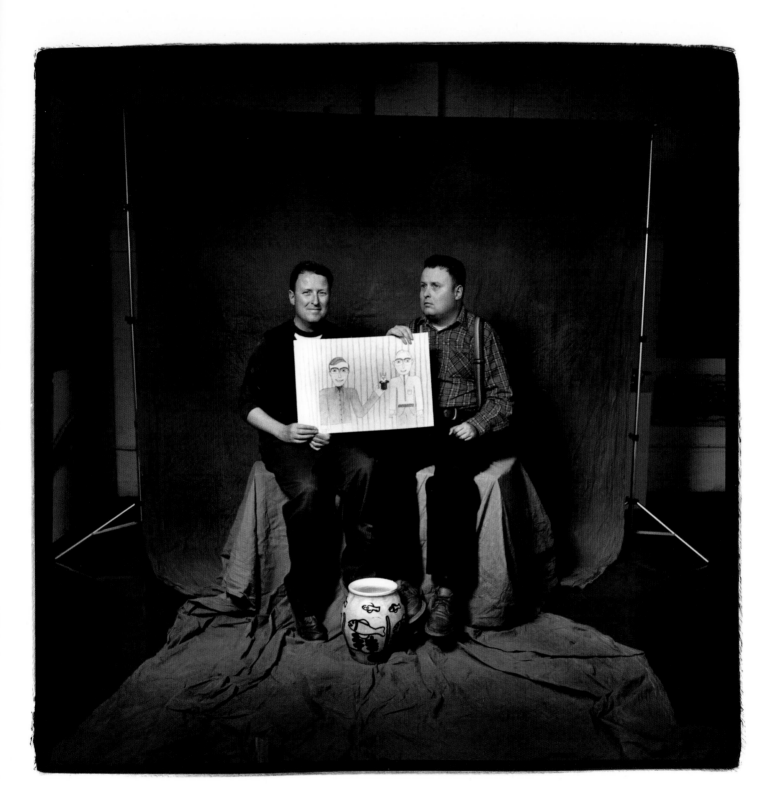

RICHARD TYLER / WILLIAM TYLER

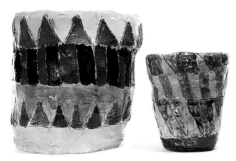

CERAMIC, 14" x 12", 8" x 6"

I like clay.
I like to be happy.

Do you like your photograph?

I don't like my hair.
Here, hair no good. I don't like. No good.

ALice
uNg

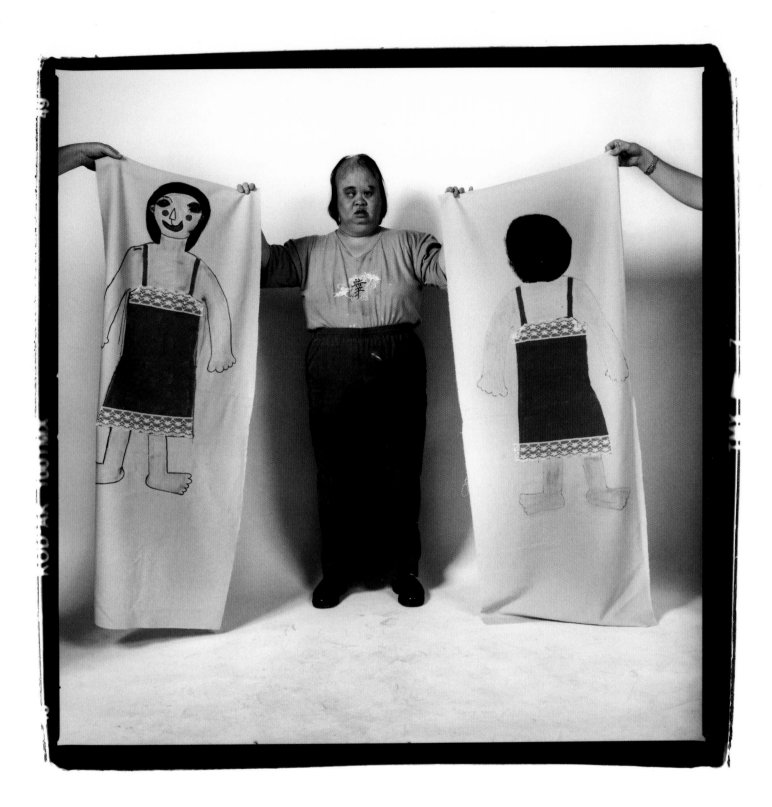

ALICE UNG

I like to paint woman
I like to wear she sitting
she holding the kitty
she like kitty
she holding her hair
there leaf all round her fall
I was holding the Picture
I. to come here as a friend

Ronald Veasey

LATEX PAINT ON WOOD, 36" x 11" (each piece)

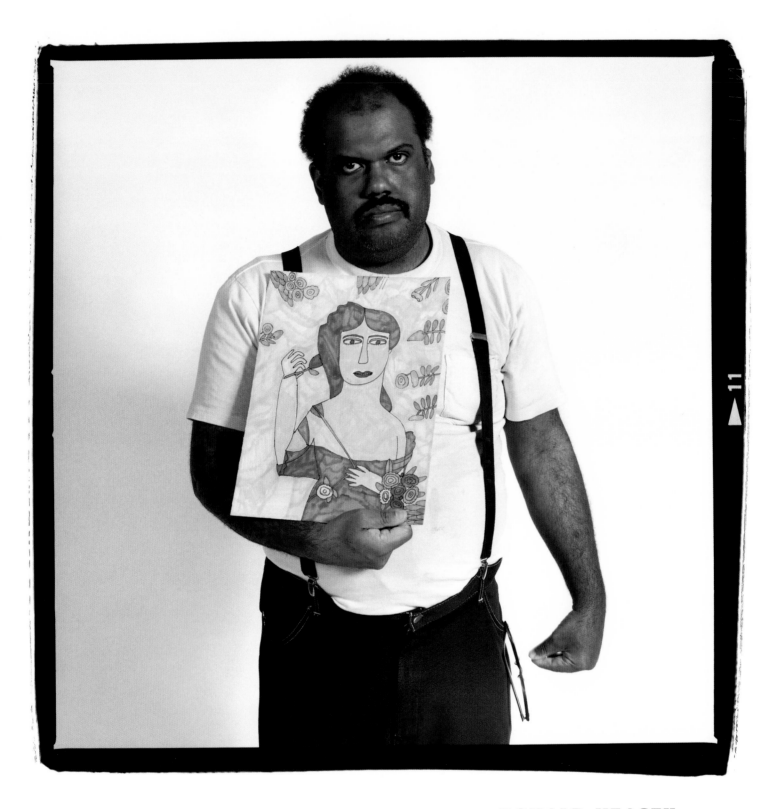

RONALD VEASEY

I like my work.

I come here for 20 years.

I like to draw people. People.

I have pencil at home. I do art at home.

I like here at Center.

My favor person is Mary Louise Irvin,
she is catering truck driver.

I like to be in show. I had picture
of birds there.

OIL PASTEL, 22" x 30"

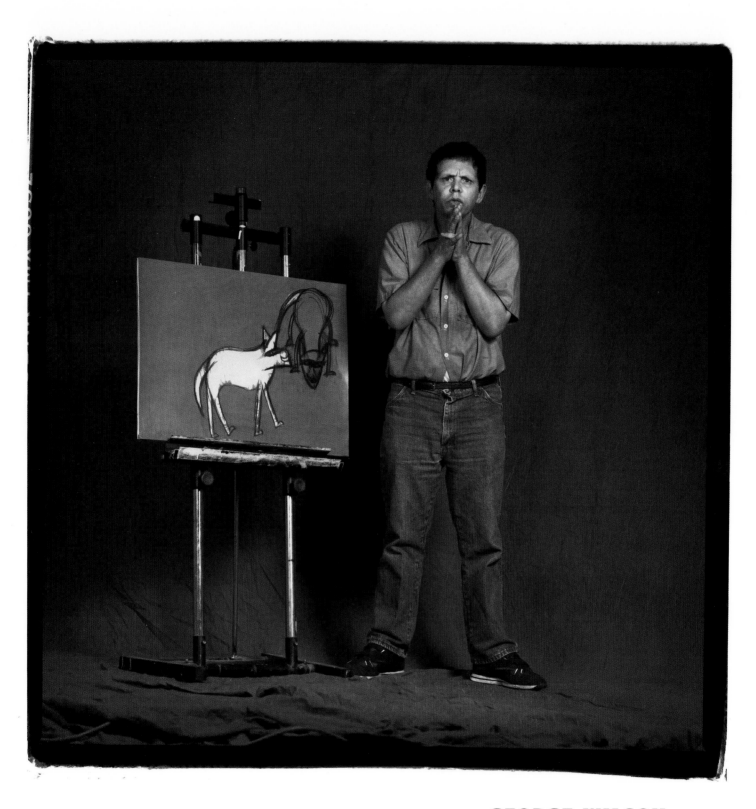

GEORGE WILSON

Despite his limited dexterity, Edwin renders intricate fields of form and color. His mosaic-like drawings are brightly colored, yet restful, bringing to mind stained-glass windows. Stubborn about change, he insists on doing things his way.

EDWIN

PRISMACOLOR STICK, 24" x 18"

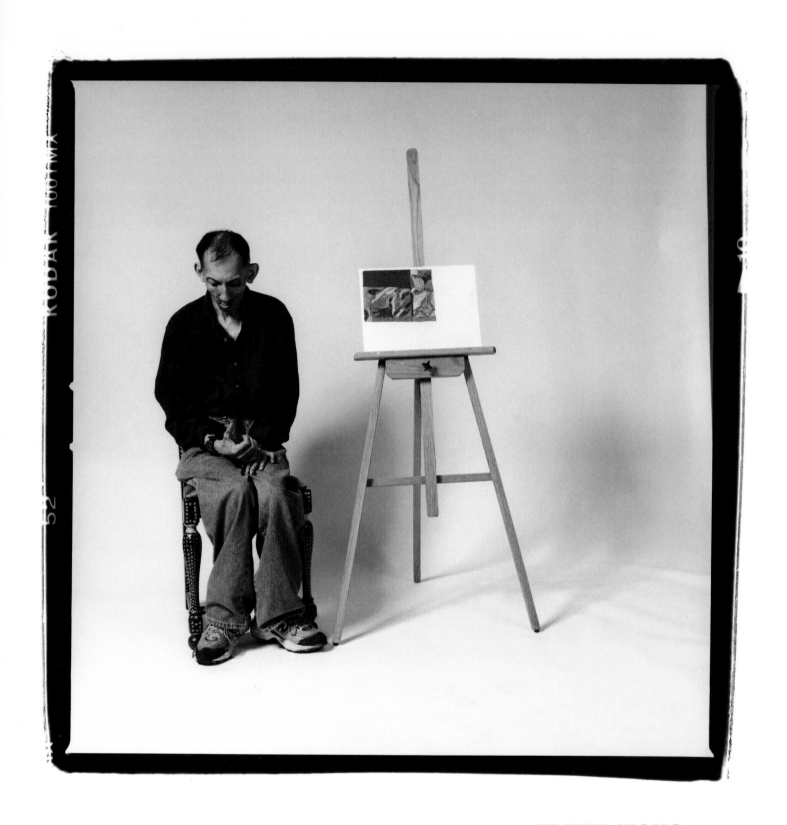

EDWIN WONG

BIOGRAPHIES

JUAN AGUILERA

BORN:GUANAJUATO, MEXICO, OCTOBER 2, 1966

Juan immigrated to the United States from Mexico at the age of eight. He returns there often to visit his family. His understanding of and pride in his heritage is apparent in the beautiful ceramic vessels he sculpts and the sweet vignettes of rural life he depicts in his drawings and linocuts.

LUIS AGUILERA

BORN: SAN SALVADOR, EL SALVADOR, FEBRUARY 22, 1973

Luis greets every day with a grin on his face and a joke up his sleeve. His drawings of monsters and dinosaurs reveal an affinity for the fantastic that is informed by icons of popular culture.

MERLIN ANTOINE

BORN: SAN PABLO, CALIFORNIA, FEBRUARY 27, 1949

Merlin moves and works with great serenity, applying layer upon layer of Prismacolor to create his color field drawings. His mysterious marks accumulate slowly, resulting in serene, almost meditative surfaces.

SHERRIE ARADANAS

BORN: KEENE, NEW HAMPSHIRE, NOVEMBER 25, 1964

With a cheerful smile, Sherrie speaks fondly of cats and professes an admiration for Xena, the Warrior Princess. The good-natured imagery in Sherrie's artwork reflects her positive, optimistic outlook on life.

MARY ARGENTIERI

BORN: LOS BANOS, CALIFORNIA, MAY 8, 1944

With a gentle sense of humor and a true enjoyment of her art, Mary paints and draws steadily at Creative Growth five days a week, creating lively and colorful designs and working with her artist friends.

IDRES BATTEN

BORN: OAKLAND, CALIFORNIA, MARCH 14, 1961

Working in energetic bursts punctuated by periods of rest, Idres makes wonderful black-and-white line drawings of animals and people, with a graphic line that is quick and sure. He also loves to sing.

ASYA BLANKENSHIP

BORN: BERKELEY, CALIFORNIA, MARCH 21, 1974

Asya is an ambitious blind artist who sees with her hands. Despite her blindness, she copes with this impairment and other physical problems with grace and elegance. As she shapes bowls, works with fiber, and stitches elaborate samplers, she is exploring meaning, techniques, and skills.

TERRI BOWDEN

BORN: OAKLAND, CALIFORNIA, JULY 14, 1962

In a recent conversation about cartoons in the new millennium, Terri expressed a vision of a city shaped like fruit: sky-rise pineapples, department stores bursting like gourmet apples and pears; a "fruitopia" of succulent color on the Oakland skyline. She interjected with a chuckle, "Don't eat the banana!"

REGINA BROUSSARD

BORN: LOS ANGELES, CALIFORNIA, SEPTEMBER 5, 1943

Regina makes pastel and Prismacolor drawings, primarily portraits of the people and places around her. Images of food and squirrels appear repeatedly in her work, which is characterized by a confident graphic line and strong, flat patterns of color.

KIMBERLY CLARK

BORN: CONCORD, CALIFORNIA, JUNE 1, 1980

A sweet, soft-spoken woman whose dedication to her art is apparent in all her work, Kim enjoys drawing teenage celebrity portraits in her own realistic style. She is skilled at both drawing and painting.

PAUL COSTA

BORN: SOMERVILLE, MASSACHUSETTS, MAY 19, 1929

Small, shy, and unassuming, Paul has been attending Creative Growth for twenty-three years and has been dating his sweetheart, Mary, for many of those years. He works by painting figures along the periphery of the paper, turning the paper as he goes.

DONALD COUGHRAN
BORN: VALLEJO, CALIFORNIA, SEPTEMBER 8, 1950

Donald is a serious, independent, and conscientious artist with a wry sense of humor that comes through in his art. His use of heavy line and stylized figures evoke a sense of nostalgia for the days of his youth.

KERRY DAMIANAKES
BORN: ALAMEDA, CALIFORNIA, DECEMBER 15, 1949

Working in a bold and colorful style, Kerry creates images of her favorite foods, using clean and simple form bounded by strong black line work. Her expressionistic drawings of fish, flowers, animals, and food reflect her dynamic personality.

RAYDELL EARLY
BORN: OAKLAND, CALIFORNIA, SEPTEMBER 5, 1952

It is rare to find Raydell unaccompanied by his utility tray, overflowing with tiny pieces of pastel sticks. In solitude and always standing, he executes his large, complex, brightly colored geometric drawings.

ANTHONY ENG
BORN: OAKLAND, CALIFORNIA, FEBRUARY 15, 1970

Anthony's mischievous streak is apparent from the first encounter with him. Boyish, playful, and friendly, he delights in trips to Disneyland, carnivals, and circuses. His drawings and small, charming ceramics are humorous and whimsical.

LOUIS ESTAPE
BORN: BIRTH CITY UNKNOWN, HONDURAS, MAY 21, 1938

Much of Louis's work depicts his religiosity: saints, angels, cherubim, and God. He also often depicts himself in his art.

ROBERT FEISE
BORN: SPOKANE, WASHINGTON, APRIL 6, 1931

Robert, who is severely afflicted with cerebral palsy, uses his computer to communicate very effectively. He creates emotionally stirring poetry, prose, sculptures, and paintings, using a long-handled brush for his canvas work.

JACQUELINE FRANK
BORN: OAKLAND, CALIFORNIA, APRIL 24, 1965

Jacqueline's colorful wooden animals, each with a gentle and friendly presence, delight both children and adults.

WILFORD FREEMAN
BORN: OROVILLE, CALIFORNIA, MAY 19, 1934

Wilford uses his Native American heritage as inspiration for his wistful drawings of houses, Native Americans, and Western landscapes, which speak of a noble and proud history.

EVA GARRETT
BORN: BIRTH CITY UNKNOWN, TEXAS, BIRTH DATE UNKNOWN,1918

While at Creative Growth, Eva painted flowery romantic landscapes, many of which wound up hanging over fireplace mantels around New England. Her paintings have all the charm of early American work and may be fittingly described as folk art.

JADE GONZALES
BORN: MARTINEZ, CALIFORNIA, FEBRUARY 21, 1986

Jade was introduced to Creative Growth via the Summer Scholarship program. His objective was to be able to render cars in a more three-dimensional fashion.

GLORIA GONZALEZ
BORN: MANAQUE, NICARAGUA, JUNE 10, 1970

A practitioner of the art of looking, Gloria works intently, often cupping an object she is observing in the palm of her hand like a wonderful secret. Her paintings often appear larger-than-life, their brilliant colors and arabesque lines revealing worlds that most people routinely overlook.

ELEANOR HACKETT
BORN: BOISE, IDAHO, SEPTEMBER 24, 1915

Eleanor is a mentally disabled artist with vision, hearing, and speech problems. She has been attending Creative Growth Art Center since 1985, during which time her drawing, painting, and tapestry-design skills have developed.

CARL HENDRICKSON
BORN: BIRTHPLACE UNKNOWN, SEPTEMBER 9, 1951

Carl is afflicted with cerebral palsy, which keeps him confined to his wheelchair. His specialty is woodworking; he has made several one-of-a-kind wooden chairs. He is also adept at creating devices that enable him to make art more easily.

SUZAN HERNANDEZ
BORN: DALLAS, TEXAS, JUNE 30, 1962

DIED: 2002

Suzan, a severely disabled young woman, spent every moment of her short life hooked up to an oxygen tank. Despite disabilities such as heart problems and Down syndrome, she enjoyed her time in the Creative Growth art studio. Susan was a pleasant, friendly young woman.

CAMILLE HOLVOET
BORN: SAN FRANCISCO, CALIFORNIA, JUNE 30, 1952

Camille is a highly productive artist who projects her intimate memories, obsessions, fantasies, and fears into her art with amazing creativity, colorful intensity, and heartrending accuracy. She tries to cope with her disability by attempting to control every aspect of her world, a control that is tenuous at best.

SHIRLEY HOW
BORN: BIRTHPLACE UNKNOWN, DECEMBER 15, 1959

Shirley is a fragile young lady with a very tough spirit. When she first came to Creative Growth she was very serious and a bit withdrawn, but she soon blossomed in her art expression and received great praise for her works in gallery exhibitions.

CEDRIC JOHNSON
BORN: BIRTH CITY UNKNOWN, TEXAS, NOVEMBER 30, 1952

Cedric's skill lies in his expressive interpretations of the human figure in abstract, colorful, cubist styles of portraiture. He also works in 3-D. Over the past twenty years, his style has evolved in complexity.

GEORGE KELLOGG
BORN: AURORA, MISSOURI, NOVEMBER 1, 1930

DIED: JANUARY 18, 1997

George developed his interest in music in the 1940s, listening to Charlie Parker, Miles Davis, and Dizzy Gillespie while living in New York City. His interest in human psychology led to an exploration of portraiture and the development of a uniquely expressionistic style. George's later works feature the jazz greats whose music he admired for most of his life.

ALLAN LOFBERG
BORN: BERKELEY, CALIFORNIA, AUGUST 5, 1955

Allan is a quiet but friendly man who thoroughly enjoys drawing and painting. His work often begins with a photographic reference, but he quickly steers it into an abstract realm. Applying color in a vigorous, free-form manner, he creates multilayered collages of colors and shapes.

DWIGHT MACKINTOSH
BORN: BIRTHPLACE UNKNOWN, BIRTHDATE UNKNOWN, 1906

DIED: 1999

Identified by the well-known art historian John MacGregor as a great American Outsider Artist, Dwight Mackintosh defied academic experts; after fifty-six years in institutions he began his artistic odyssey to fame and great renown, demonstrating the indomitable nature of the human spirit.

CHAVA MALKA
BORN: NEW YORK, NEW YORK, FEBRUARY 29, 1956

Chava's lyrical line drawings have garnered rave reviews at the Center's gallery exhibitions. Her sensitivity in a variety of media captures the character and life of her subjects with surprising minimalism.

JOHN MARTIN
BORN: MARKS, MISSISSIPPI, FEBRUARY 24, 1963

Artist Joe Sam describes the art of John Martin: "John's works of art, with their wonderful sense of vibrant colors and images reflect and dramatize the emotional intensity of the moment in urban life."

DANIEL MILLER

BORN: CASTRO VALLEY, CALIFORNIA, JULY 11, 1961

Dan's artwork reflects his persona and his perception. Letters, words, and images are repeatedly overdrawn, often to the point of obliteration or destruction of the ground. Images of obsessional objects, such as light-bulbs, routers, or electrical sockets, which inhabit his speech, are reiterated.

DONALD MITCHELL

BORN: SAN FRANCISCO, CALIFORNIA, SEPTEMBER 15, 1951

Diagnosed with moderate mental retardation and schizophrenia, Donald is now a much-sought-after Outsider Artist. His rows and rows of static, chunky figures with impenetrable gazes are characteristically Mitchell. He explores this theme over and over again in different media, seducing his audience and causing them to wonder about these silent, anonymous crowds.

CHARLES NAGLE

BORN: BERKELEY, CALIFORNIA, FEBRUARY 18, 1959

Charles's work is broad and painterly, made up of colorful and energetic strokes. His interests in the world around him are all included in his abstracted repertoire: landscapes, planes, cars, sports, and movie personalities. The physicality of Charles's work belies the frail man one meets in the studio. But just a short conversation with him reveals the boundless enthusiasm that he brings to his art.

BRIAN NAKAHARA

BORN: BERKELEY, CALIFORNIA, FEBRUARY 5, 1982

Brian's avid love of sports is reflected both in his art and in his involvement as an athlete in numerous events in the Special Olympics. First introduced to art through the Summer Scholarship program, Brian creates wood, ceramic, and acrylic homages to sports teams and sports heroes that have been collected by likeminded enthusiasts.

DONALD PATERSON

BORN: SILVER SPRINGS, CALIFORNIA, MAY 5, 1944

While at Creative Growth, Donald was exceptionally prolific, working in almost all media, and he learned quickly through direct observation. Lofty design and decorative detail filled his drawings. He was also skilled in ceramics and sculpture.

MAX QUESADA

BORN: WALNUT CREEK, CALIFORNIA, APRIL 27, 1979

When Max enrolled in Creative Growth, he was one of the youngest artists in the program. His ceramic landscapes demonstrate a talent for envisioning and realizing a series of complex and comprehensive universes. His distinctive, otherworldly aesthetic presents a dramatic dialogue with the mysterious side of fantasy.

AURIE RAMIREZ

BORN: SANGLEY, PHILIPPINES, OCTOBER 7, 1962

Aurie's skill is exceptional and her subject matter is vast in her complicated watercolor paintings. She incorporates her own language into her entirely original, distinctive paintings with occasional recognizable words.

STANLEY REXWINKLE

BORN: COFFEYVILLE, KANSAS, AUGUST 8, 1961

Stanley, who has worked as a poet, a songwriter, a musician, a magician, and even a mail screener at the White House mail room, draws on his memories and dreams as source material for his surreal narrative drawings and paintings. He injects his unique sense of humor into his work.

DIANE RHODES

BORN: PALO ALTO, CALIFORNIA, NOVEMBER 21, 1959

Diane joined Creative Growth in 2002. She quickly adapted to the studio environment and began using long-handled paintbrushes to make bold, abstract acrylic paintings. Here work is evolving as she explores drawing and ceramics, and experiments on landscapes and flowers.

ADAM ROMERO

BORN: SAN FRANCISCO, CALIFORNIA, MAY 28, 1976

Adam has a marvelous sense of humor and enjoys playing tricks on people such as hiding under the table when he is being called. His ready smile and nonverbal ways of communication keep the Center's staff amused. In his artwork he employs bright color and simple imagery.

MARIANA RUYBALID
BORN: DENVER, COLORADO, JANUARY 23, 1950

Mariana is a poet and an activist for the rights of the disabled. She explores various art techniques and media. She plans to illustrate her next book of poetry with her delicate black-and-white line drawings. She also serves on the board of Creative Growth Art Center.

FEYCHAN SAEPHAN
BORN: BIRTH CITY UNKNOWN, LAOS, FEBRUARY 20, 1959

Feychan doesn't communicate verbally but is easily understood through her gestures. Her endearing, shy smile and demure manner are reflected in her smiling ceramic gargoyles.

JUDITH SCOTT
BORN: COLUMBUS, OHIO, MAY 1, 1943

Judith Scott is a fiber artist who is isolated from outside influences because of the severe impact of deafness and Down syndrome. She is very independent and self-directed. Crafting armatures of bamboo slats or other discarded materials, she wraps these forms with lengths of knotted cloth or yarn. Her sculptures reflect little cultural input and are highly individualistic, expressing Judith's own personal vision.

WILLIAM SCOTT
BORN: SAN FRANCISCO, CALIFORNIA, BIRTH DATE UNKNOWN, 1964

William is looking for love, his search a part of a greater quest for the elusive "normal life" of "everyday citizens." A self-taught artist capable of rendering his subjects with remarkable accuracy and meticulous detail, William focuses his work on a long-standing obsession with and reverence for the quintessential African American female beauty.

DINAH SHAPIRO
BORN: BERKELEY, CALIFORNIA, DECEMBER 26, 1963

Dinah carries a sketchbook with her wherever she goes, filling it with ideas for drawing and prints. Dinah also enjoys looking at the work of other artists and the art of other cultures. She is a generous, sociable woman who shares her excitement about creativity and art making with other artists in the studio. Dinah's paintings, drawings, prints, and ceramic sculpture are brightly colored and elaborately patterned.

ERNEST SPEARS
BORN: BIRTHPLACE UNKNOWN, SEPTEMBER 17, 1929

Ernie is a visionary expressionistic painter. He enjoys drawing and painting portraits and desert landscapes. He has an enduring crush on Marilyn Monroe, a frequent subject of his work.

SHARON SPENCER
BORN: DETROIT, MICHIGAN, AUGUST 26, 1944
DIED: 1999

Because of her disability, which occurred in the middle of her art career, Sharon was forced to paint with her mouth using an adapted brush. Her portraits have great charm and are realistically precise. She had the ability to capture the mood of a scene in the difficult and delicate medium of watercolor. Her work reflects her positive attitude and her appreciation of life.

GERONE SPRUILL
BORN: OAKLAND, CALIFORNIA, OCTOBER 16, 1973

An aspiring DJ with an encyclopedic music collection, Gerone possesses a street-smart graphic sensibility that pulsates with the visual rhythm of hip-hop beats. His Prismacolor and ink drawings take the form of extensive, if not epic, comic-book narratives that chronicle the misadventures of his characters, memorably coiffed and infinitely cool, as they cruise Chocolate City in pursuit of rap stardom and other kinds of "satisfaction."

GREGORY STOPER
BORN: BERKELEY, CALIFORNIA, SEPTEMBER 22, 1969

Gregory draws and paints in sudden bursts of energy. The artworks themselves, however, are quiet and still. Gregory's favorite images are rows of houses and trees. He colors his images with solid, vivid hues.

RICHARD TYLER
BORN: CINCINNATI, OHIO, APRIL 23, 1954

Richard is a quiet man who lives in a world of his own. He paints and draws in a unique, unmistakably "Outsider" style that reflects his perceptions of the things around him. He draws representational images, delineating the outline of the objects and imbuing them with the qualities of a still life.

WILLIAM TYLER

BORN: CINCINNATI, OHIO, APRIL 23, 1954

William's precise, ordered drawings reflect a fascination with fantasy and reality and the blurred line between the two ideas. William draws freely using his personal experience and cultural icons to create a symbolic place where order reigns over emotion but make-believe rules equally with reality.

ALICE UNG

BORN: OAKLAND, CALIFORNIA, SEPTEMBER 15, 1962

Quiet and focused, Alice works independently and untiringly. She often draws the female figure, rendering it stylistically her own. These figures are depicted in frontal views, confronting the observer directly, no matter what reference material she uses.

RONALD VEASEY

BORN: LAS VEGAS, NEVADA, SEPTEMBER 9, 1957

Ron is a quiet, careful, and thorough artist. He works slowly and independently, indirectly absorbing art techniques. His paintings and drawings have a precise graphic line and a straightforward composition, which he executes with flat, vivid colors.

GEORGE WILSON

BORN: OAKLAND, CALIFORNIA, MARCH 17, 1946

George is a man of few words, usually offering only a whispered comment as he moves quickly through the studio. His eyes and hands are always in motion and his art reflects this. His drawings of dogs, horses, people, and places swirl in front of our eyes, charged with brilliant color and kinetic energy.

EDWIN WONG

BORN: HONG KONG, CHINA, AUGUST 23, 1939

Although Edwin is quite a fragile person, he moves rather well with the help of his walker. His art is abstract, repeating the same motifs in many of his works. Slow, methodical, and patient in his work, he carries an air of mystery with him.

ACKNOWLEDGMENTS

I am moved by the generous spirit of the clients at Creative Growth who gave of themselves so freely, allowing me to document their many intriguing, revelatory, and often surprising insights.

Irene Ward Brydon, former executive director, strongly supported this project. Tom di Maria, current executive director, facilitated many obstacles with understanding and continuous support. The entire staff of Creative Growth deserves mention, especially Stan Peterson for his unwavering enthusiasm and deep insights with regard to the artists and their art.

Further acknowledgments go to:

Erick Himmel, for envisioning this project as a book.

Debra Lande, without whose enthusiasm this book would not have come to light. We were always on the same page and her support was constant.

Carey Jones, for her effort and tolerance with my requests for deadline extensions.

Sara Schneider, for turning the materials into these fine finished pages.

Mark Coleman and Mark Jones, for shaping the initial visual concept of the book.

The Guggenheim Foundation, for their support.

Jim Hormel and Tim Wu, for their generous financial support.

"In Their Own Words," the interviews with the artists, was made possible, in part, by a grant from the California Council for Humanities as part of the Council's statewide California Stories Initiative.

John M. MacGregor, for his insightful essay for this book. His uncompromising high standards, his wisdom and vast knowledge of the field of Outsider Art greatly expanded my own understanding of this complex subject.

Reagan Louie, for being there for me through the birthing process. I am indebted to him for his constant encouragement and critical eye.

John Killacky and Rene de Guzman, for offering the exhibition at Yerba Buena Art Center.

Rena Bransten, who not only represents me at the Rena Bransten Gallery in San Francisco, but is also a cherished friend.

Ruth Silverman and Larry Sultan, for their assistance.

Lastly, Arlene, for her enthusiasm, for believing in me, and for her help with the English grammar that makes no sense to me whatsoever.